IMAGES
of America

TARPON SPRINGS

Dolores Kilgo

ARCADIA

Published by Arcadia Publishing,
an imprint of Tempus Publishing, Inc.
2 Cumberland Street
Charleston, SC 29401

Printed in Great Britain.

Library of Congress Catalog Card Number: 2002112083

For all general information contact Arcadia Publishing at:
Telephone 843-853-2070
Fax 843-853-0044
E-Mail sales@arcadiapublishing.com

For customer service and orders:
Toll-Free 1-888-313-2665

Visit us on the internet at http://www.arcadiapublishing.com

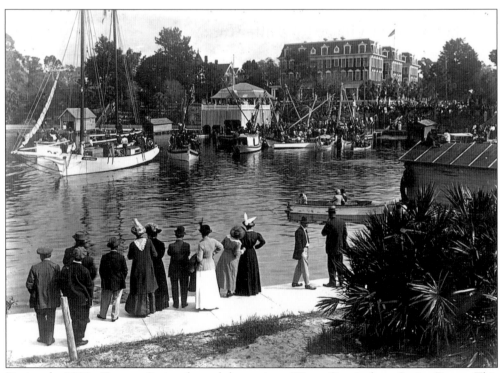

During the 1920s, Tarpons Springs hosted three winter Water Carnivals on Spring Bayou. This photograph shows well-dressed spectators viewing the bayou events at the 1925 carnival.

4/26/03

To my beautiful & long time friend of many years Naomi "Fountain" Cronk with fond memories & much love.

Clara Sauter

IMAGES
of America

TARPON SPRINGS

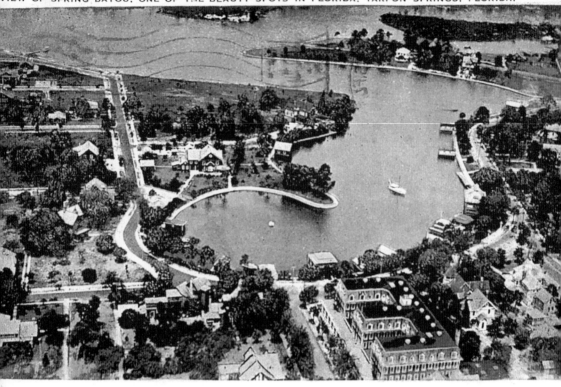

An 1896 writer, describing the most unique and appealing features of Tarpon Springs, was especially enchanted by its "charming bayous winding in and around picturesque islands and high-banked peninsulas." This 1920s postcard provides an aerial view of the city's beautiful bayous.

CONTENTS

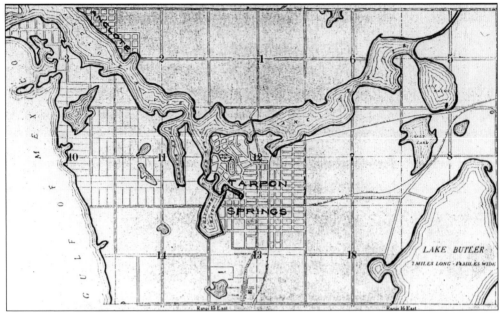

This map appeared in *Book of Views: Tarpon Springs, Florida: "The Venice of the South*, a promotional booklet published *c.* 1914 by the Tarpon Springs Board of Trade.

ACKNOWLEDGMENTS

I would like to express my gratitude to the following individuals and institutions for their assistance with this project: Winona Jones at the Palm Harbor Historical Society Museum; Don Ivey at the Heritage Village Pinellas County Historical Museum; Wendy Buffington; Ruth Connor; Clinton Kaminis; George Karaphillis; Nick Kavouklis; Rachel Spilman; Florida Belle Tarapani; John Tarapani; Barbara Vinson; and members of the Tarpon Springs Area Historical Society's Board of Directors. Thanks also to Rob and Amy Kilgo, who first encouraged me to explore the history of Tarpon Springs and to my husband, Bob, for his help as an astute editor.

I would also like to acknowledge the contributions made by Robert F. Pent, author of *History of Tarpon Springs* (1964) and George Frantzis, author of *Strangers at Ithaca* (1962). Both books were helpful resources. Like all who attempt to write about Tarpon's history, I am especially indebted to Gertrude Stoughton for her outstanding work in *Tarpon Springs, Florida: The Early Years* (1975). I would also like to thank Arcadia Publishing for developing its *Images of America* series. These books provide a unique and important service in bringing to light historical photographs that otherwise would never be generally accessible. And, we should all thank the dedicated early photographers whose efforts preserved these remarkable glimpses of the past.

Finally, this book would not have been possible without the encouragement and ongoing assistance of Phyllis Kolianos, former curator and manager of the Tarpon Springs Area Historical Society and Museum. Her expert knowledge of local and regional history was invaluable and impressive.

INTRODUCTION

Tarpon Springs, the northernmost city in Pinellas County, is approximately eight miles north of Clearwater and 30 miles from Tampa. It is a place rich in history, cultural diversity, and striking natural beauty. The photographs included here tell the story of how this small Gulf Coast town came to be one of Florida's most picturesque and historically interesting communities.

The history of Tarpon Springs begins in the late 1860s when the Anclote River area was still a wilderness frontier. The region had once been occupied by Tocobago Native Americans, who disappeared in the 18th century, and later by the Seminoles. The first white settlers arrived in the area in 1867, building cabins along the banks of the beautiful Anclote River. Located on the north side of the river, their settlement became the tiny village of Anclote, which was three miles west of present-day Tarpon Springs. The settlement of Anclote is an important part of the history of Tarpon Springs. Nearly a decade passed before other pioneers came to the area to settle on the inland bayous. For a time, the few settlers in the region lived a peaceful, isolated existence, enjoying the area's lush beauty and rich natural resources. All of that changed dramatically after 1881, when young Hamilton Disston, a shrewd Philadelphia businessman, pulled off the largest real estate deal in Florida's history.

Disston was a friend of Florida's governor, William Bloxham. In a desperate effort to save his state from bankruptcy, Bloxham sold Disston 4 million acres of state land for 25¢ an acre. To retain title to the land, Disston agreed to drain and convert the swampland sections into habitable areas. Although he acquired a substantial amount of "swamp and overflowed" land, he also obtained some choice Florida property, including some 70,000 acres in present-day Hillsborough and Pinellas Counties. He selected the Tarpon Springs locale for its potential as a winter resort location.

In 1882 Disston sent his associate Anson P.K. Safford to the Tarpon Springs area to develop a community that would attract hard-working respectable residents, affluent seasonal visitors, and northern capital. The able and dedicated Safford, a former Arizona Territorial governor, quickly achieved that goal by successfully promoting the area as "the gem of the Disston purchase." Today Safford is recognized as the founder of Tarpon Springs.

In 1887 Tarpon Springs became the first incorporated town in what was then Hillsborough County. By this time, the community was flourishing as the first fashionable winter resort area on Florida's Gulf Coast. Some winter visitors came as short-term tourists; others, primarily the families of northern millionaire industrialists, became regular seasonal residents. Their Victorian mansions encircling Spring Bayou soon made Tarpon Springs the most attractive town in the region. In addition, with nearly 500 residents by 1890, Tarpon Springs had become the largest town on the Pinellas Peninsula.

The 1890s proved equally important for another aspect of commercial development in Tarpon Springs. In 1891, John Cheyney, a local businessman, outfitted the area's first sponge fishing boat. He also founded the Anclote and Rock Island Sponge Company at Bailey's Bluff, near the mouth of the Anclote River. The new industry, which created the first Gulf Coast market for harvested sponges, attracted scores of sponge boats to Tarpon's coastal waters, where local spongers vied for harvests with the highly competitive Key West "Conchs." Hostilities between the two factions sometimes erupted into fights and

even boat burnings. These early sponge boatmen worked in relatively shallow waters, not far offshore, where they used hooks on long poles to snag and retrieve the sponges.

Tarpon Springs continued to grow and prosper as a coastal community and a winter resort through the turn of the century. In 1911, it became part of Pinellas County, which was formed from a portion of Hillsborough County. By the 1920s, cooperative efforts between civic leaders and prominent winter residents had earned the city a wide reputation as the cultural center of the region. During the winter season, there were daily concerts in the park, many featuring nationally known musicians. The Spring Bayou water carnivals, held annually in the mid-1920s, were statewide attractions. These elaborate celebrations featured boat races, illuminated boat parades, and musical and theatrical performances on floating stages. By the late 1920s, Tarpon Springs was being promoted as the "Venice of the South" to bring attention to its beautiful bays and bayous.

The city's rapid growth after the turn of the century was directly related to developments that forever changed the character of the community. In 1905, John Cheyney hoped to expand his sponge business by hiring John Cocoris, a young Greek immigrant. Cocoris convinced Cheyney that the Greek practice of gathering sponges through diving would allow them to harvest miles of rich offshore sponge beds that lay far beyond the reach of the hooker's pole. In 1905, with Cheyney's support, Cocoris brought the first Greek divers with mechanized diving equipment to Tarpon Springs. Many of their countrymen soon followed. By 1907, there were several hundred Greek immigrants living near the city's newly constructed sponge docks and warehouses. By the 1930s, when the Tarpon sponge fleet numbered 200 boats, the Greek divers, boatmen, and boat builders had made the sponge industry a multi-million dollar business locally. Tarpon Springs was recognized as the sponge capital of the world until the late 1940s, when bacteria destroyed the Gulf Coast sponge beds. Although harvesting and selling sponges still play a role in the local economy, tourism is now the dominant business in the city.

Among Florida's Gulf Coast communities, Tarpon Springs has an unusually romantic and diverse history. Its transformations over time are vividly recalled in the memorable photographs that follow. Many of these images have not been previously published. Unless otherwise noted, all photographs reproduced in this book are from the Tarpon Springs Area Historical Society Collections.

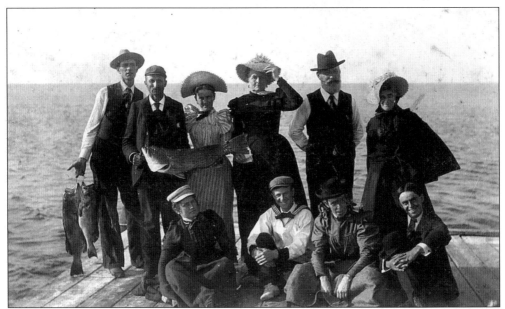

From the late 1880s to the turn of the century, Tarpon Springs was the most fashionable resort on Florida's Gulf Coast. Some early tourists came for the climate. Many others came to fish. The invention of the steel rod and reel in the 1880s inspired an army of new fishing enthusiasts and Florida's Gulf Coast earned a wide reputation as a fisherman's paradise by the 1890s.

One

EARLY SETTLERS ON THE ANCLOTE AND THE BAYOUS

The Anclote River, which winds its way some 15 miles from its headwaters to the Gulf, has always played an important role in Tarpon's history. This turn-of-the-century photograph shows that picturesque river, which was named by early Spanish mapmakers. Anclote in Spanish means a light anchor used in smooth, shallow water. The term is also loosely translated as "safe harbor." Seminoles called the river Eschasotte, which means "lair of the manatee."

Just above Tarpon Springs, the Anclote River flows around a maze of flat, marshy islands. Beyond these marshes, the main stream of the river turns north and then east, twisting and turning its way through stands of tall timber, dense jungle, and exotic tropical terrain. Only the most experienced explorers attempted to maneuver through the hairpin curves, menacing sandbanks, and nearly impenetrable jungle to reach the river's remote headwaters located at Seven Springs.

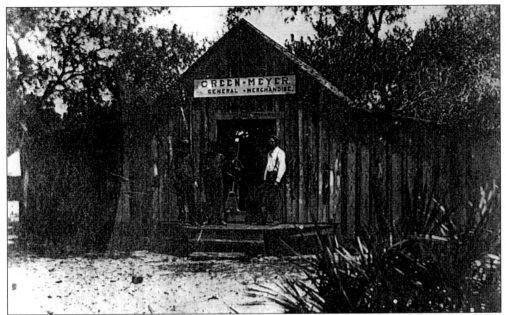

The first families in the Tarpon Springs area settled along the north banks of the Anclote River, arriving there in 1867. Other hearty pioneers joined them over the next decade, building cabins nearby. Their settlement, called Anclote, was the earliest settlement on the Pinellas Peninsula and was locate about three miles west of present Tarpon Springs. This late 1890s photograph illustrates the first general store in the village operated by Green Meyer, whose family founded Anclote. (Courtesy of Gene and Barbara Vinson Collection.)

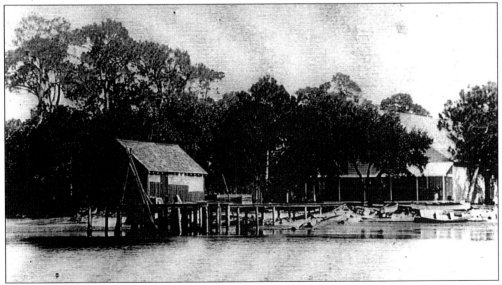

Hoping that salt air might protect them from malaria, Frederick and Benjamin Meyer, along with their families, left plantations near Ocala to come to the Gulf Coast area, where they became the first settlers at Anclote. Although both brothers soon died of yellow fever, their families stayed on to build a life in the wilderness. By the 1890s, their settlement had grown into a village. This shows the dock and an early warehouse at Anclote. (Courtesy of Gene and Barbara Vinson Collection.)

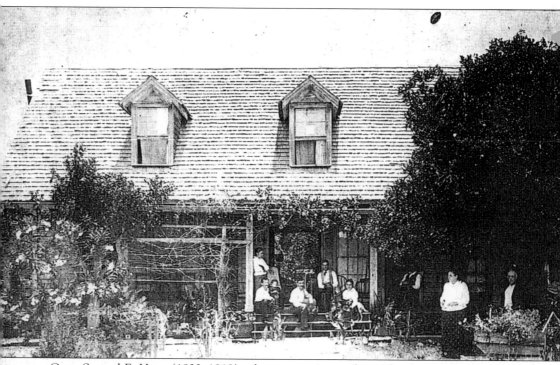

Capt. Samuel E. Hope (1833–1919), who grew up in northern Florida, was the first person to purchase land along the Anclote River. In 1858, after serving in the Second Seminole Indian War, Hope became a surveyor. He was the first surveyor to map the Anclote area. During the Civil War, he was captain of the "Brooksville Guards," and later served with distinction with Finegan's Brigade at the Second Battle of Cold Harbor in Virginia. He was wounded at Petersburg, Virginia, in 1864. After the war, Hope served several terms in the Florida state legislature, representing Hernando County. This c. 1900 photograph pictures Hope and his family at their home in Anclote. Hope stands in the yard at the far right of the picture, near his wife, Mary, who was the daughter of prominent Florida pioneer William Brinton Hooker. (Courtesy of Gene and Barbara Vinson Collection.)

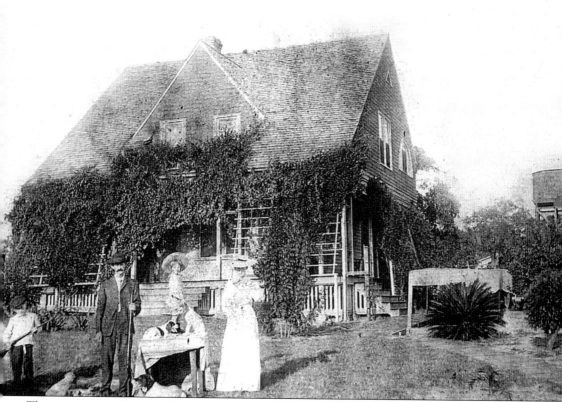

This vine-covered cottage that once stood in Anclote was the home of Robert S. Meyer, who built this house with his younger brother, Wyatt. Robert and Wyatt were two of seven children born to Anclote pioneers Benjamin and Sarah Meyer. This house stood next to the old family home place on Meyer Cove. Robert lived here when he worked as assistant keeper at the Anclote Key Lighthouse in 1889 and for a time later, when he took a break from his work at the lighthouse. He served as keeper at the lighthouse from 1891 to 1914, and again from 1923 to 1933. In 1869, Wyatt Meyer was the first child born in the Anclote settlement. Since Meyer family records indicate that the brothers shared this house, it is not certain which family has gathered here in the yard for the photographer. Regardless, the young child and the two pups perched on the table were remarkably cooperative subjects. (Courtesy of Gene and Barbara Vinson Collection.)

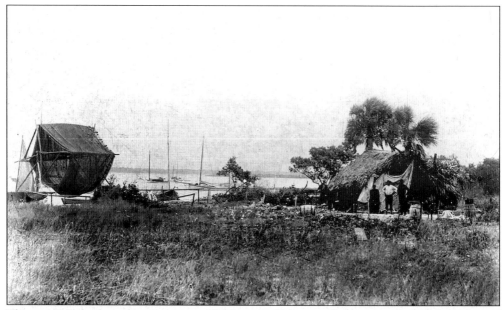

This c. 1890 photograph pictures one of the many "fish camps" that once dotted the shores of the Anclote River, when fishing was the major local industry. An 1885 brochure listed the most plentiful fish in the area as the sheepshead, grouper, red snapper, saltwater trout, and mullet. It also noted that although mullet "afford much amusement in leaping into the air, they never take the bait and have to be netted." The early Anclote fisherman seen here fished for mullet using the large net on the rack in the foreground.

This undated photograph probably shows an early Anclote resident traveling on the old military wagon trail that came to be called the Anclote-Brooksville Road. At that time, the road was still much like the rough trail that soldiers had cleared through the dense wilderness terrain during the Seminole Wars in the 1830s. Brooksville is about 35 miles northeast of Tarpon Springs.

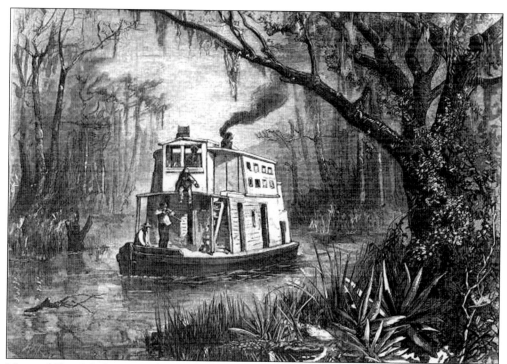

Many of Florida's first tourists came to hunt or fish the region's exotic wildlife. As this 1874 illustration from *Harper's Weekly* shows, alligators were eagerly pursued by amateur hunters and most were shot from the decks of river steamboats. Tarpon's Anclote River, where "seven and eight-foot gators" reportedly abounded, undoubtedly attracted its share of hunters.

In 1924, a Tarpon Springs newspaper deemed the Anclote River "the most picturesque, most tropical thing we have to offer our northern visitors." The writer went on to note that tourists cruising the river were especially fascinated by "the gators [which] always elicit exclamations of wonder and surprise." This early photograph taken on the Anclote may have been a tourist's memento of an eagerly anticipated alligator sighting.

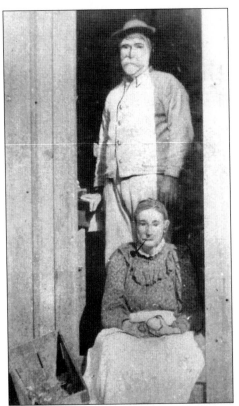

In 1864, while the Civil War raged in the North, William and Julia Thompson settled on homesteaded land about three miles south of present-day Tarpon Springs. They were the first settlers in the region to locate south of the Anclote River. The Thompsons, seen in this later portrait, were farmers who migrated from northern Florida to plant the first citrus groves in the area. (Courtesy of Palm Harbor Historical Museum.)

William Lawrence Thompson and his wife, Julia Holland Thompson, are recognized as the first permanent settlers in Pinellas County. Their first cabin and citrus groves were located south of Alderman Road. In 1910, when their family citrus business was well established, their oldest son, William B. Thompson, bought this Tarpon Avenue home as a part-time city residence for the family. The newly restored property is now known as the Thompson-Jukes House. (Courtesy Florida State Archives.)

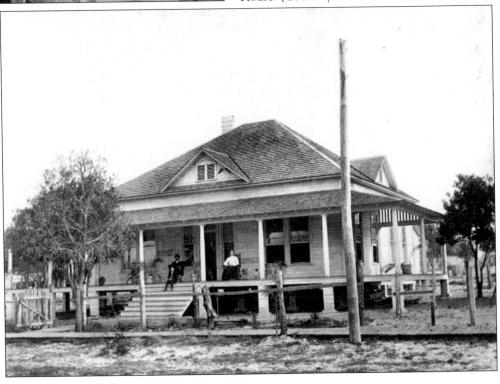

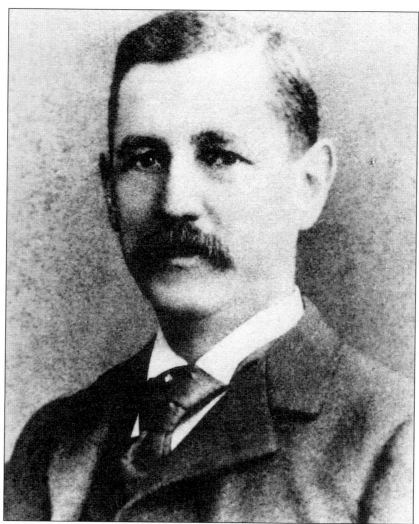

Hamilton Disston (1844–1896), a successful saw manufacturer, discovered Florida and its Gulf Coast on annual fishing excursions with wealthy Philadelphia friends. During his travels to the state, he made friends with Florida's governor, William Bloxham. At that time, Florida was in financial ruin. In 1881, in an effort to save his state from bankruptcy, Bloxham sold Disston four million acres of Florida land for 25¢ an acre, a transaction that made the 36-year-old Philadelphian America's largest landowner. To retain title to the land, Disston agreed to drain and convert swamplands into habitable areas. Much of the property that he bought as officially designated "swamp and overflow land" turned out to be high and dry, and some of the most desirable property in the state. Disston's acquisitions included some 70,000 acres in present-day Hillsborough and Pinellas Counties. Within this area, he designated Tarpon Springs and the Lake Butler area as the most promising sites for winter resorts. By the mid-1880s, Tarpon Springs and its environs were being described as "the gem of Disston's purchase." During the Panic of 1893, the ambitious developer suffered financial losses that shut down his Florida operations. Disston died in 1896. Many early accounts of his life state that he committed suicide.

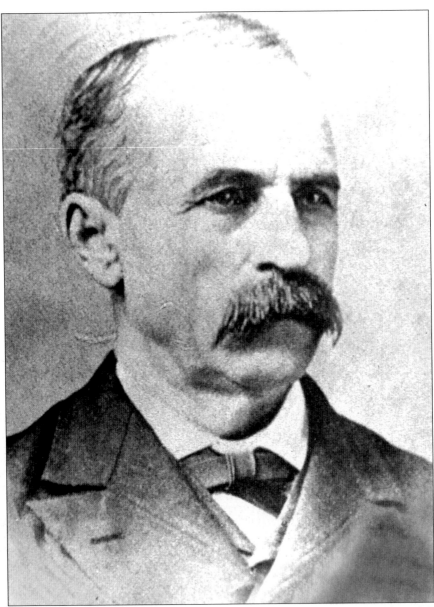

The Vermont-born Anson P.K. Safford (1830–1891), considered the founder of Tarpon Springs, was an extraordinary individual. Before coming to Florida's Gulf Coast in 1882, he had been a miner, an Indian fighter, surveyor general of Nevada, and a successful politician in the rugged Far West. Following the Civil War, Anson served two terms as territorial governor of Arizona, where he founded the public school system. In Tarpon Springs, Safford was always respectfully referred to as "The Governor." When Safford left Arizona to take up banking in the east, he met with Hamilton Disston in Philadelphia. Impressed with the young man's plans, Safford invested in the project and agreed to become president of Disston's new Lake Butler Villa Company, which would develop both the Lake Butler property and Tarpon Springs. In 1882, he arrived in Tarpon Springs on the heels of Disston's surveyor, who had just laid out a plan for the new city. Until his death in 1891, the generous, kind, but forceful Safford worked tirelessly to make Tarpon Springs an attractive progressive community.

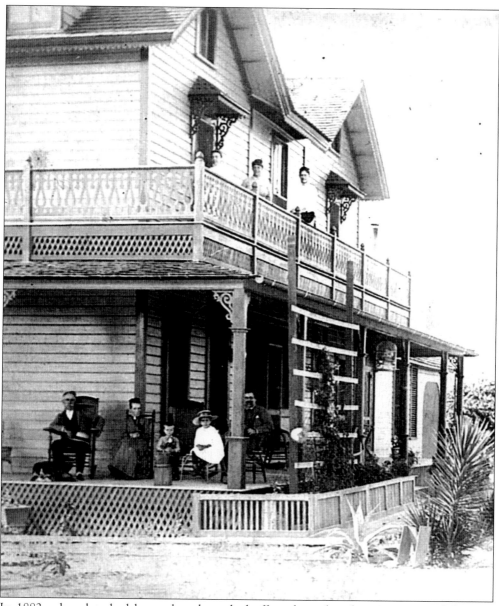

In 1882, when lots had been platted, marked off, and numbered, construction of the new community began. A.P. Safford's home was located on the new street named Spring Boulevard. When he purchased the property, the house was a small twin-gable cottage. This c. 1886 photograph shows the home after Safford added a second story, a cupola, dormers, and porches. "The Governor," on the far left, is seated on the porch with his family. The woman to his right is his sister, Dr. Mary Jane Safford, Florida's first practicing female physician. After Safford's death, his widow sold a large portion of their corner lot, and the house was moved about 100 yards northwest toward the back of the lot to its present location at 23 Parkin Court. In 1903, George Clemson built a $70,000 mansion on the Saffords' original home site at the corner of Spring and Grand Boulevards. The Safford House was placed on the National Register of Historic Places in 1975 and was donated to the city in 1995. It has been extensively renovated and restored and will soon be open to the public.

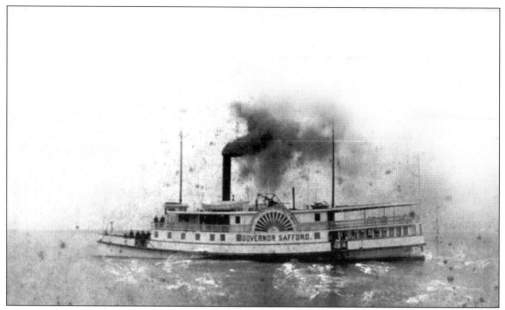

Before the railroad came to Tarpon Springs, nearly all freight and travelers came by boat from Cedar Keys. This side-wheel steamer, the *Governor Safford*, made regular trips between Cedar Keys and Tampa. To discharge passengers and freight headed for Tarpon Springs, the 150-passenger steamer docked at a covered pier near the mouth of the Anclote River. The *Mary Disston* then transported the travelers and cargo up the river to the city pier. (Courtesy Florida State Archives.)

Dating from the late 1880s, this photograph shows the *Mary Disston*, a wood-burning steamer built for Hamilton Disston and named after his mother. The shallow draft steamer, seen here at Tarpon Springs City Dock, was able to navigate the Anclote River's shallow winding channels. The picture was taken by A.B. Paxton, a photographer working out of Gulf Key, Florida in 1886.

Lake Butler, renamed Lake Tarpon in 1949, is about a mile southeast of Tarpon Springs. It was originally named in 1848 for Col. Robert Butler, Florida's first surveyor general. The seven-mile-long freshwater lake was part of Hamilton Disston's Florida real estate purchase. In 1882, envisioning a lucrative development project, Disston deeded 9,500 acres of land surrounding the lake to his newly formed enterprise, the Lake Butler Villa Company. Anson Safford came to Tarpon Springs to run the company and promote the project, which eventually involved more than 20,000 acres.

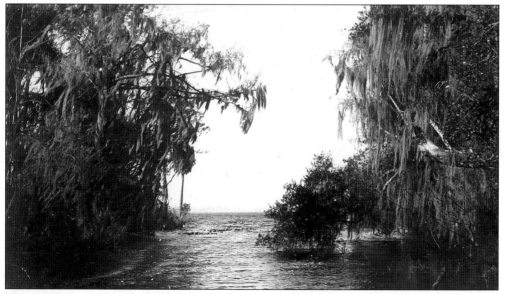

This c. 1890 view of Lake Butler's scenic shoreline at Brooker's Creek was among many early photos made to promote Lake Butler Villa properties to northern investors and potential lot owners. Despite the high hopes and aggressive promotions of company officials, the Lake Butler Villa project lagged behind Tarpon's rapid development as a successful resort center. The company, gradually selling off its properties, existed until 1969. Today Lake Tarpon is known as one of the foremost bass fishing lakes in Florida.

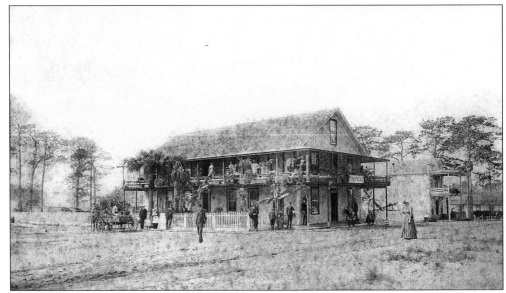

The Tropical Hotel pictured here was the first official hotel in Tarpon Springs. Built by Safford's group in 1883, it was an enlarged bunkhouse that had originally housed workers brought in to build the city. Managed by Walter and Amelia Meres, the Tropical appears to be a thriving operation in this *c.* 1884 photograph. The hotel was located at the southwest corner of Tarpon and Pinellas Avenues.

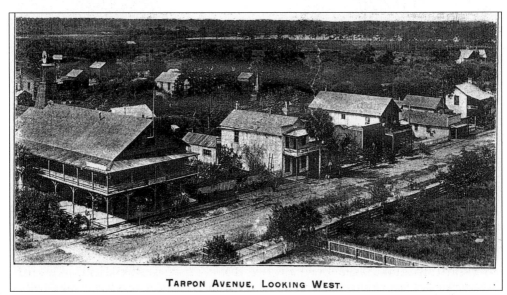

TARPON AVENUE, LOOKING WEST.

A photo-derived engraving, this sweeping bird's-eye view of Tarpon Avenue looking west shows the Tropical Hotel on the corner. The building next to the hotel housed the town's first store and post office, both operated by Edward Blum, who lived above the store. At the time of this *c.* 1890 photograph, Tarpon Springs had a population of about 500 people.

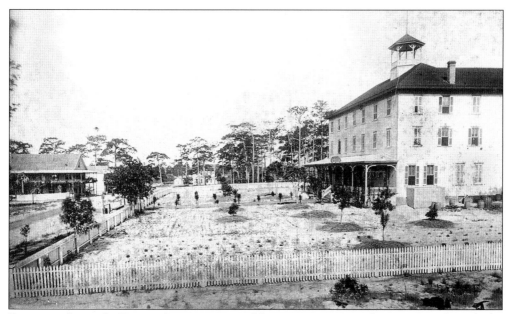

Determined to make Tarpon Springs a successful winter resort, Hamilton Disston, through the Lake Butler Villa Company, financed the construction of the elegant Tarpon Springs Hotel in 1884. The three-story, seventy-room structure was the town's most imposing building. Surrounded by newly planted citrus trees, it was located between Tarpon Avenue and Orange Street, near the present site of St. Nicholas Cathedral. The hotel was destroyed by fire sometime around 1900.

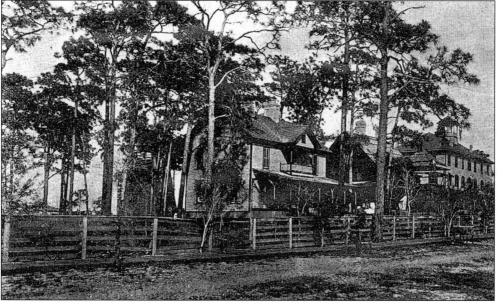

To accommodate more winter residents in the 1890s, the Tarpon Springs Hotel added several large cottages next to and behind the main hotel building. This view from Tarpon Avenue shows the front of the hotel and cottages. For $2 a day, guests at the Tarpon enjoyed steam heat, electric lights, and fireplaces in every room. Just across the street, at the more modest Tropical Hotel, the daily rate was $1.50.

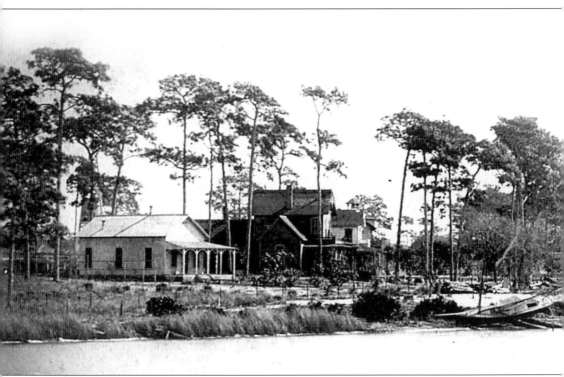

This c. 1886 panorama is one of the earliest known views of Spring Bayou, the smallest of the city's four saltwater bayous. This beautiful, protected cove was named for the deep spring that periodically surged upward above the bayou's normally placid waters. This view, which looks east across the water, shows some of the first houses built on Spring Boulevard, the street that curves along the head of the bayou. On the far left is the Massey

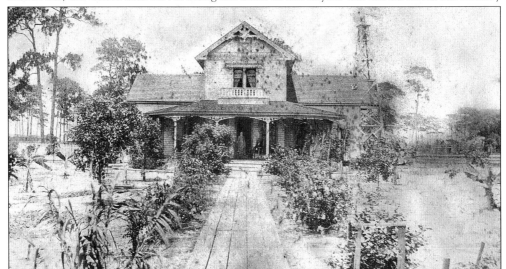

Little is known about Seymour Thornton, one of Governor Safford's first neighbors on the newly created Spring Boulevard. Thornton built this Victorian "cottage" sometime before 1885, when this picture was taken. The Alworth home currently stands on the site of the Thornton cottage.

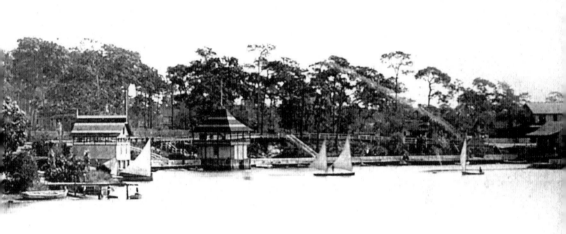

home, which no longer exists. Moving to the right along Spring Boulevard is the De Golier house, which was built around 1883; the Thornton house; and the Safford home. The Gregg house, located at the opposite end of Spring Boulevard, is visible on the far right side of the picture. At this early date, only three boathouses have been constructed on the bayou.

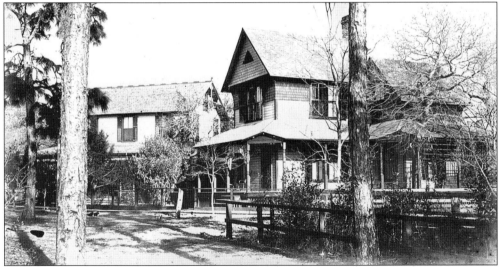

Myron E. "Cappy" Gregg, a wealthy businessman and avid sailor who came to retire in Tarpon Springs in 1883, was typical of the men who built the first homes on Spring Boulevard. Gregg built his home at 69 Spring Boulevard, the large house in the center of this picture, as a year-round residence. The owner of the large home at the left of the picture remains a mystery.

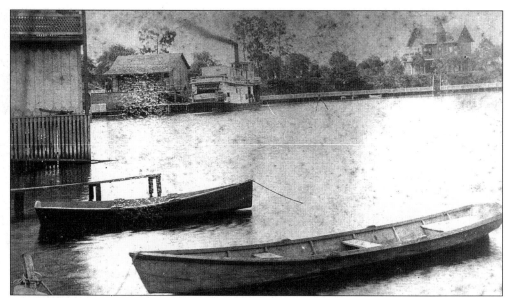

In this 1880s view looking south across Spring Bayou, the *Mary Disston* sits at the city dock, black smoke billowing from her smokestack. The landscape on the distant shore is dominated by the imposing form of the Knapp house, which was, by far, the most ambitious of the early homes built along the bayou. Like most of the town's influential newcomers in the 1880s, Edwin Knapp was a wealthy retired businessman who made Tarpon Springs his year-round home.

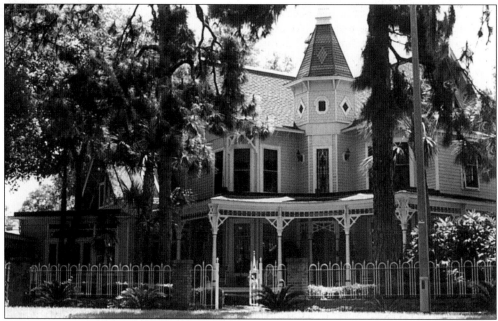

A closer view of the beautifully restored Knapp home reveals its builder's taste for Victorian curves and crescents. Indeed, the house was called "Crescent Place" because of the crescent motifs that appear in designs throughout the house and on its exterior. Known affectionately as "the Admiral," Knapp was an accomplished sailor and president of the local yacht club. He also chaired the 1887 meeting where residents voted to incorporate Tarpon Springs as a city.

Tarpon Springs had all the requisites for a successful winter resort—sunshine, sea breezes, fresh citrus, and the obligatory "medicinal" spring. In the 1890s, on the advice of their doctors, wealthy invalids flocked to warm seaside locations, especially places where mineral springs provided additional therapy. Shown in this c. 1885 photograph, the famous "medicinal" spring was on the east side of Spring Bayou, just north of the city dock. The spring flowed up into a receptacle protected under the pagoda-like springhouse seen in this picture. The pensive young lady in the foreground may have been retreating from the potentially healthful, but somewhat foul-smelling sulfur content in the spring's "medicinal" waters.

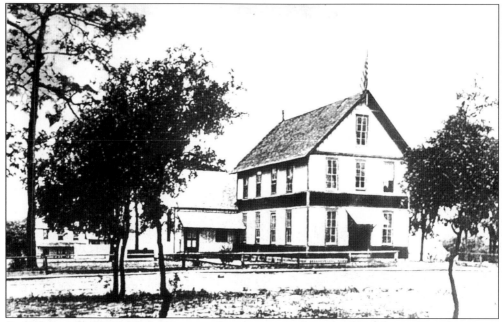

On February 12, 1887, 34 of 46 registered voters met in this school building, where they voted to incorporate Tarpon Springs as a city in what was then Hillsborough County. At the same meeting, they elected officers of the new city government, including the first mayor of Tarpon Springs, Wilbur De Golier. This new school building, which still stands on North Pinellas Avenue, was built in 1886 or early 1887 to replace the first small schoolhouse built by Governor Safford on Court Street.

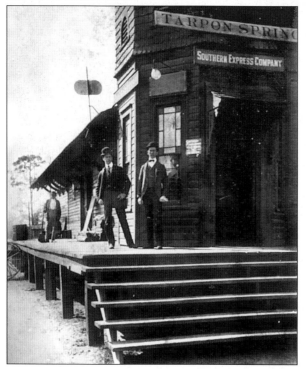

The long-awaited arrival of rail transportation was critical to the development of Florida's Gulf Coast communities. The Orange Belt Railroad made its first run to Tarpon Springs in late 1887. The city's first railroad station, seen in this turn-of-the-century photograph, was built in 1888 at the southwest corner of Safford Avenue and Court Street. The depot burned in 1908.

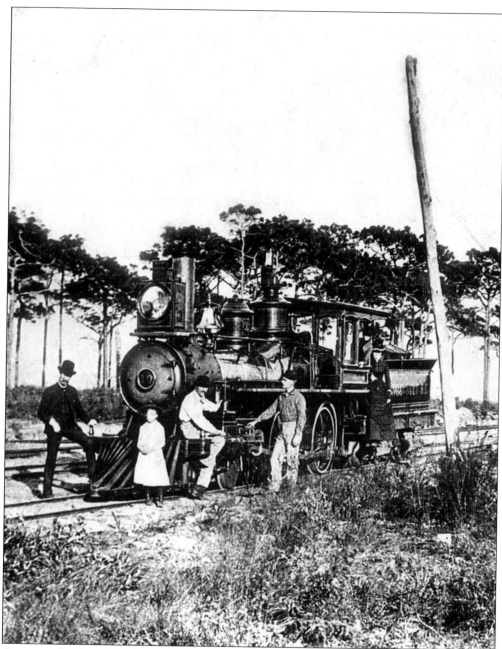

Access to the Orange Belt line dramatically increased Tarpon Springs's commercial potential. The railroad's owner, Peter A. Demens, a Russian immigrant who named St. Petersburg, overcame many obstacles with the help of Hamilton Disston. By 1888, the Orange Belt's wood-fired steam engine ran from Sanford in central Florida to its terminus at St. Petersburg. With the Orange Belt in operation, passengers could travel by train from New York City to Tarpon Springs in only 36 hours, with only one train change at Sanford. Demens went broke during the Depression of 1891 and the Orange Belt line was taken over by the Plant System. In 1902, when this picture was taken, it had become part of the Atlantic Coast Line. This photograph recorded the first Atlantic Coast locomotive on the old Orange Belt tracks.

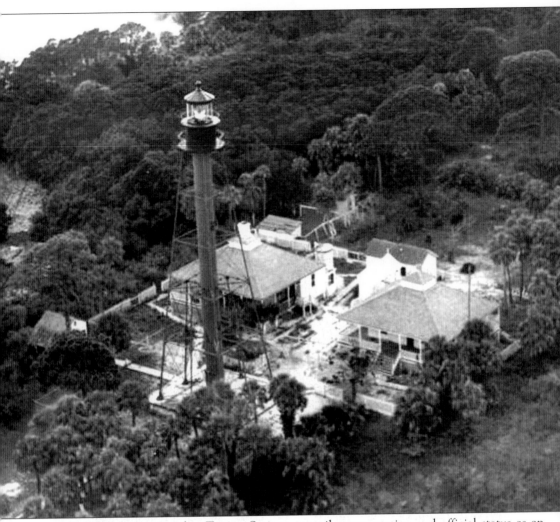

In 1887, the same year that Tarpon Springs got rail transportation and official status as an incorporated city, it also got this lighthouse on the main island of Anclote Keys, a cluster of islands sitting just off Florida's Gulf Coast near Tarpon Springs. Capt. Samuel Hope was the state legislator who wrote the bill urging the government to build a lighthouse at the Anclote Key location. Congress complied and President Cleveland declared the island a lighthouse reservation. Today the Anclote Key is a state nature preserve. With no bridge connecting the key to the mainland, visitors must make a three-mile boat trip to reach the island. In 1682, some 400 French and English pirates occupied the island while they raided trading ships and plundered settlements on the mainland. The key's only other residents were the lighthouse keepers and their families, who first arrived in 1887, when the lighthouse went into operation. The cast-iron tower seen from above in this aerial photograph was completed at a cost of $35,000. (Courtesy Florida State Archives.)

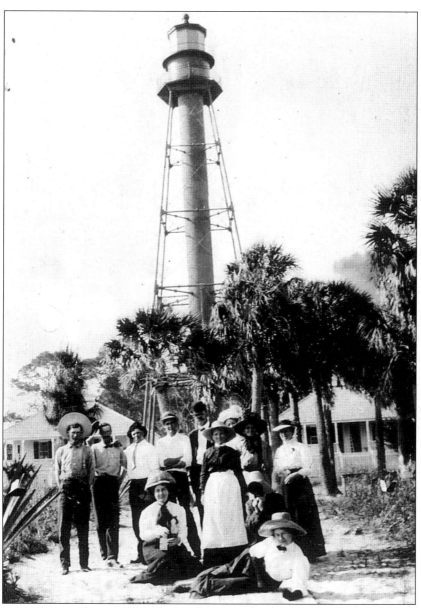

This photograph was taken in 1910, during the Meyer family's visit to the lighthouse. Seen in the background, between the palm trees and the lighthouse tower, are two identical wooden buildings situated about 50 feet from the lighthouse. These dwellings served as homes for the families of the two light keepers—a principal and his assistant. Behind the houses, the tall ironwork structure of the tower encloses a spiral staircase. The revolving turret at the top of the tower was operated by a weighted mechanism that required daily winding by the light keepers. The flashing white beam from the massive lantern, which was initially fueled by kerosene, could be seen from 16 miles at sea. The last lighthouse keeper left the island in 1952, when the tower's beacon was automated. Although the 101-foot-high structure still towers over the southern end of the island, the light at Anclote Key was decommissioned in 1984. Because of volunteer efforts, the State of Florida is currently working to restore the lighthouse to its original condition.

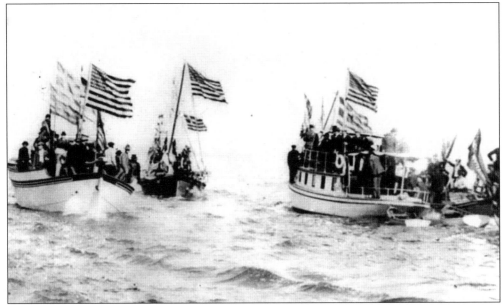

A trip to view the coastline from the Anclote Key lighthouse was an obligatory sightseeing experience for every visiting dignitary. Over the years, many important visitors, such as Greek Premier Venizelos and former vice-president Spiro Agnew, traveled to the lighthouse in launches or sponge boats. This festive regatta was probably the excursion that took Calvin Coolidge out to see the lighthouse in January 1930.

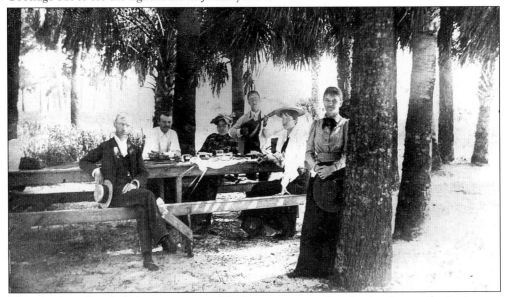

The Anclote Key lighthouse site quickly became a popular destination and picnic area for tourists and locals who enjoyed the boat trip and the striking view from the tower. The light keepers became accustomed to receiving tourists and visitors on Sundays. The site was such a novelty that some tourists were willing to make the 60-mile steamboat trip from Cedar Keys to visit the island. This *c.* 1898 scene shows a leisurely group enjoying lunch and music on the island. Sometime around the turn of the century, the light keepers built a picnic area for visitors.

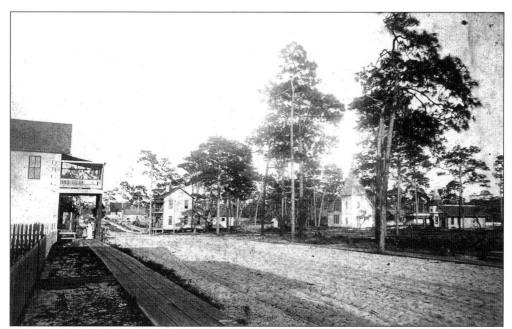

When this photograph was taken c. 1889, "downtown" Tarpon was a sparse cluster of buildings running from the city dock to the train depot. This view showing sand streets and wood plank sidewalks looks south down Tarpon Avenue toward Safford. On the left is C.D. Webster's Old Reliable Drug Store. The white building with the steeple tower is the Universalist's chapel, the first church in the city. The city's first railroad depot appears at the far right of the picture.

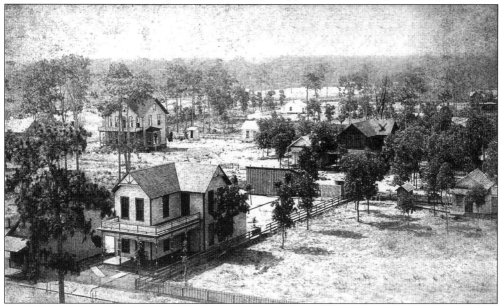

This late 1880s bird's-eye view records an expansive landscape stretching from Tarpon Avenue (at bottom left) looking south toward Court Street and beyond. The large house near the bottom of the picture is the Fowler home on Tarpon Avenue. In 1885, the price of a large lot in the center of town was $200. Lots on the bayou started at $75. Home building costs ranged from $50 for a "good log house" to $600 for a six-room, two-story cottage.

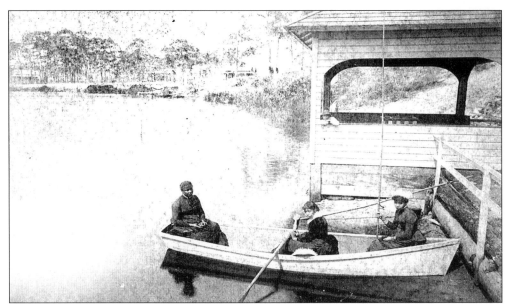

In this photograph, taken *c.* 1885, three well-dressed young women pause during an outing on Spring Bayou. The 1880 census showed nearly 900 African Americans living in Hillsborough County (which at that time included Tarpon Springs). Tarpon Springs had a growing African-American community by 1885. Many of the men worked at the lumber mill or in the sponge industry. The service skills of many of the city's African-American women played an integral role in the town's developing resort industry.

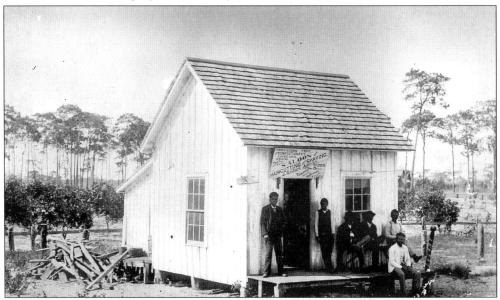

Apparently a popular hangout, this small business establishment in Patten's Quarters offered numerous products. The sign over the door advertises a variety of "Provisions," including fruit, confectionery, kerosene, tobacco, cigars, snuff, and oysters. This small general store also doubled as a barbershop and artist's studio. In the 1880s and 1890s, much of the city's African-American population was concentrated in an area on the river by Patten's Sawmill, called Patten's Quarters.

Two
From Bayou Village to Winter Resort

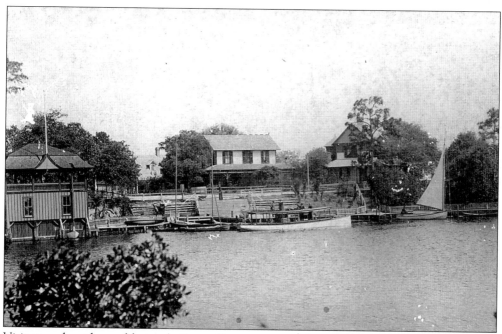

Visitors and residents alike made Spring Bayou an integral part of life in early Tarpon Springs. As this early scene of the city dock suggests, Spring Bayou was a popular site for sailing and rowing, and it was a favorite departure point for launch and yachting excursions. The city dock was located at the foot of Tarpon Avenue.

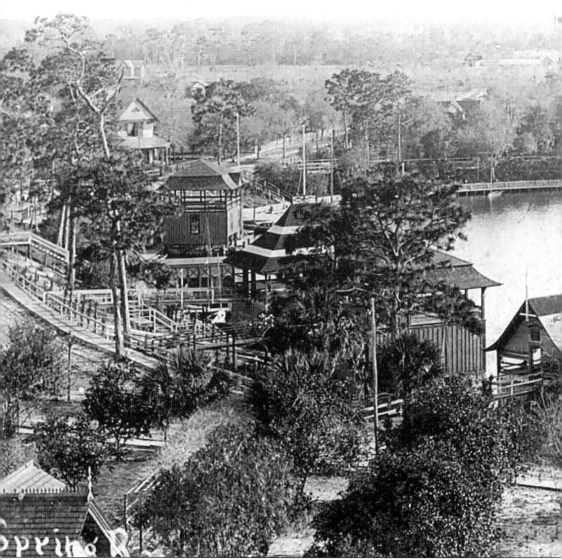

This extensive view, which shows Spring Bayou's looping southwestern shoreline, was probably taken from the top of Governor Safford's windmill. A portion of the Safford's ornate roofline can be seen in the bottom left corner of the picture. The Safford family's boathouse, in full view near the center of the picture, is directly across the bayou from the Edwin Knapp home on

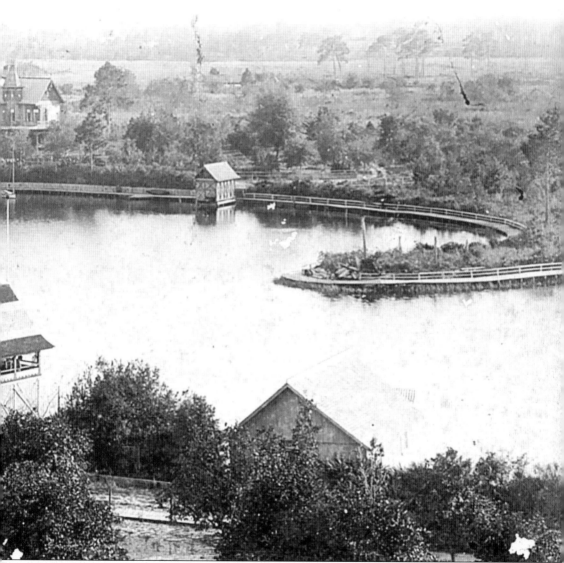

the opposite shore. In 1876, A.W. Ormond, the first settler in what is now Tarpon Springs, built his cabin near this bayou. Three years later his daughter Mary supposedly named their tiny settlement when she commented on the beautiful tarpon fish springing up out of the bayou waters.

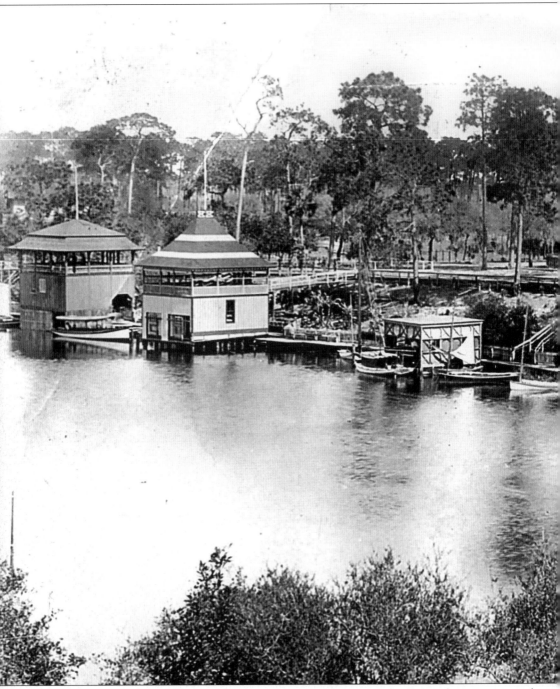

Looking north across Spring Bayou, possibly from the top of the Knapp home's tower, this panoramic vista offers a highly detailed view of the picturesque, curving shoreline. The wooden stairs leading down to the city dock can be seen at the bottom right of the picture. A wood plank walkway with handrails encircles the water, while a second tier forms a wooden promenade at the top of the bank along Spring Boulevard. By this time, c. 1890, Spring Boulevard had become an unbroken stretch of stately homes and new mansions.

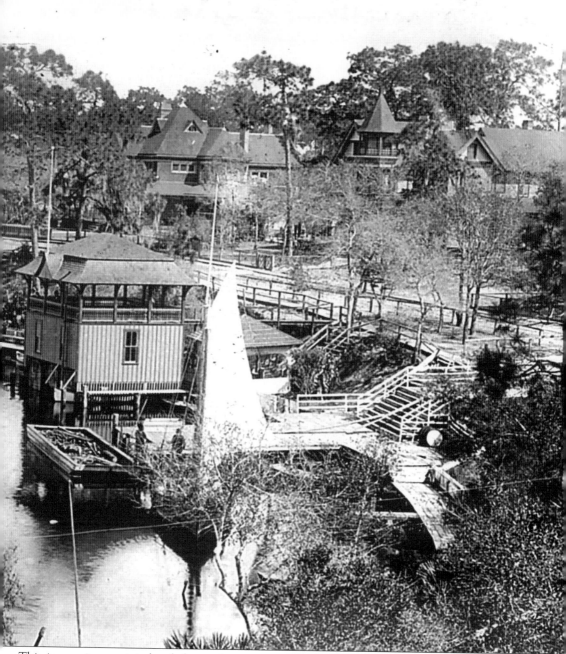

This impressive semicircle of elegant homes soon came to be called "the Golden Crescent." Several of the boulevard's most affluent residents built the picturesque boathouses that became a distinctive and admired hallmark of the city. While a number of the beautiful mansions are still standing, many restored to their original conditions, the lovely ornate boathouses did not survive.

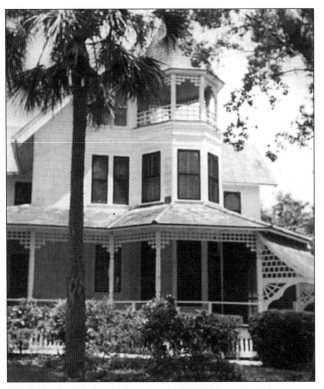

In 1887, William T. Fleming, a millionaire from Chestnut Hill, Pennsylvania, began construction of this beautiful Victorian mansion at 22 Spring Boulevard. Fleming was related by marriage to the Disston family of Philadelphia. The home, which can still be seen on the bayou, was completed by 1890. The Fleming house is similar to the Knapp house in its late-Victorian style.

Marshall Henry Alworth, owner of this Spring Boulevard home, was probably the wealthiest of Tarpon's winter residents. The Alworths came from Duluth, Minnesota, where Alworth made a fortune in timber before becoming majority owner of one of the world's richest vermilion iron-ore ranges. Although he did not share some of his neighbors' taste for elaborate exterior decoration, his 12-room home was beautifully crafted with inlaid floors and the finest cypress and pine available.

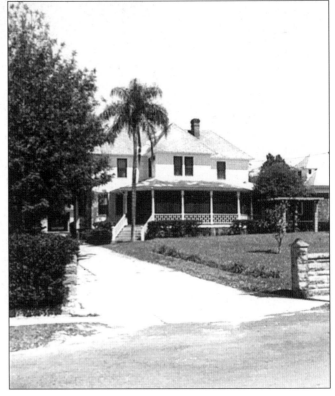

George Clemson, a hacksaw blade manufacturer from Middletown, New York, built the largest home on Spring Bayou in 1902. The size of a small hotel, his stately mansion still sits at the corner of Spring and Grand Boulevards, the former site of the Safford house, which was moved to an adjacent location. Clemson built his $70,000 winter home with master carpenters that he brought with him from the North.

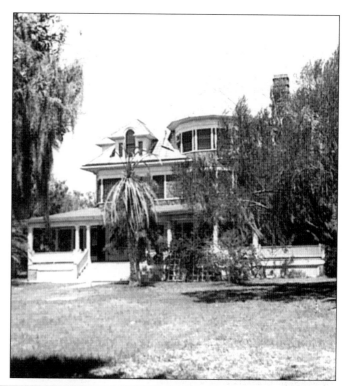

William De Golier was the city's first mayor and one of the first residents on Spring Bayou. He was a retired businessman who came to Tarpon Springs to live year-round in 1883, when he built this home on the north shore of the bayou. Its style is similar to that of the Alworth home, although an 1890 drawing of the De Golier house indicates that its exterior originally had a substantial amount of ornate Victorian trim.

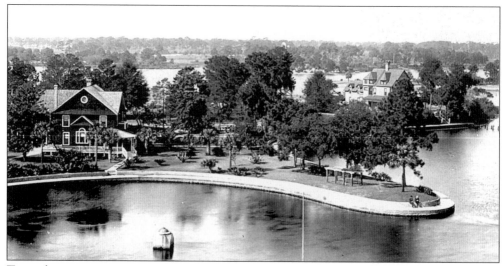

Two other impressive mansions once graced the east shores of Spring Bayou. The large house on the left, which no longer exists, was the winter home of millionaire bachelor and Minnesota state senator Ebenezer Hawkins. At the far right in the picture, on a point jutting out into the bayou, sits the Keeney-Beekman home, built in 1890. Its owner, Charles Keeney, died in 1891. His widow, Viola Keeney, who married John Beekman, later gave her home to the city for a park and library. It was torn down in the 1960s.

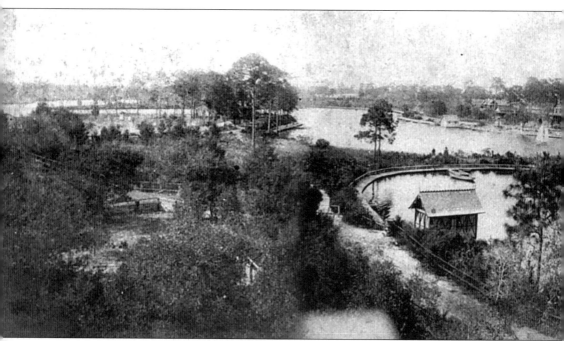

Taken in the late 1880s, this expansive view encompasses the entire length of Spring Bayou looking north beyond the point to Whitcomb Bayou in the far distance. As this photograph shows, at this early date, 90 percent of what is now Tarpon Springs was still undeveloped woodlands. The wooded area on the east side of the bayou, at the left side of this picture, is where Craig Park is located today. This photograph predates the construction of the Hawkins

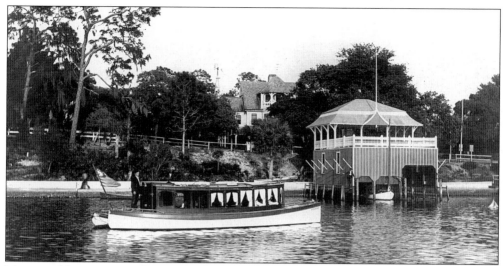

Many wealthy winter residents owned pleasure launches such as the one seen in this *c.* 1890 photograph. This may be the Fleming family's boat pulling away from William Fleming's handsome boathouse shown at the right. Little is known about the large home that sits above the boathouse on Spring Boulevard. It was apparently moved or destroyed early in the century. One unconfirmed source identifies it as "the Johnson house at the corner of Tarpon Avenue and Spring Boulevard."

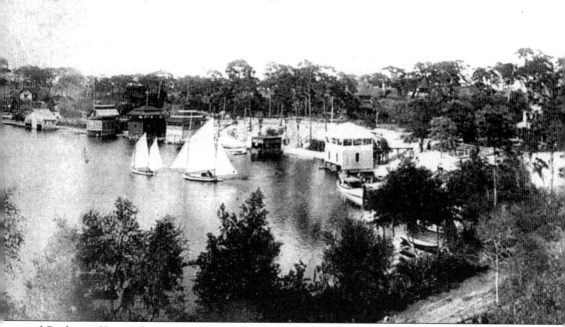

and Beekman-Keeney homes on that side of the bayou. As suggested in this picturesque scene, sailing on the smooth bayou waters was a popular recreational activity for seasonal and year-round residents alike. In 1896, Whitcomb Bayou was especially recommended for "juvenile sailors and inexperienced yachtsmen who do not care as yet to risk too deep waters."

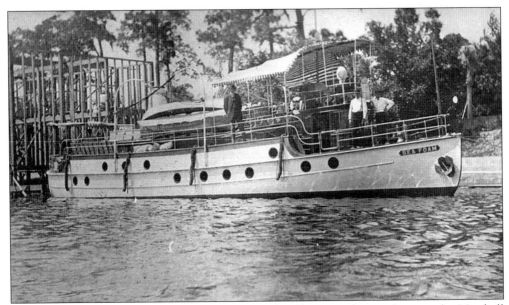

The *Sea Foam*, pictured above, was one of several yachts owned over the years by Marshall Alworth. It was a modest-looking vessel when compared to his other yachts, the *Oneida* and the massive *Marnell*. The *Sea Foam* is anchored in Spring Bayou, near a new boathouse under construction.

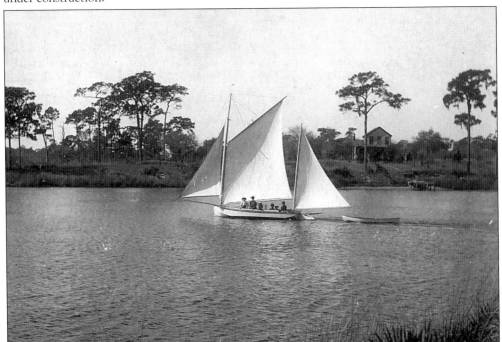

This beautiful sailboat captured by professional photographer A.B. Merritt may be one of the many boats-for-hire available to the winter visitors of Tarpon Springs by the late 1880s. This could also be members of the Women's Bayou Boat Club out on a sailing excursion. The Women's Bayou Boat Club was one of the most popular social organizations for winter residents. The setting here is probably Kreamer or Whitcomb Bayou.

44

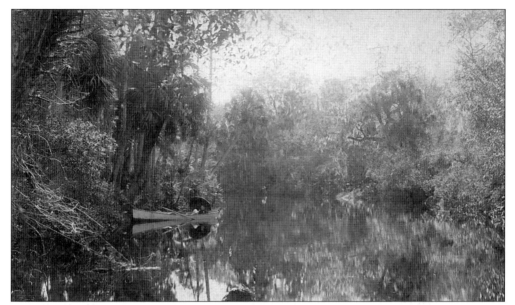

The Anclote River was one of the town's most valuable economic assets in the early years of the city's development. For tourists and winter residents, its winding shores and natural beauties added greatly to Tarpon's appeal. Photographs such as this one, taken in the 1890s by a commercial photographer, were saleable items for visitors who wanted souvenir images of their experiences touring this picturesque waterway.

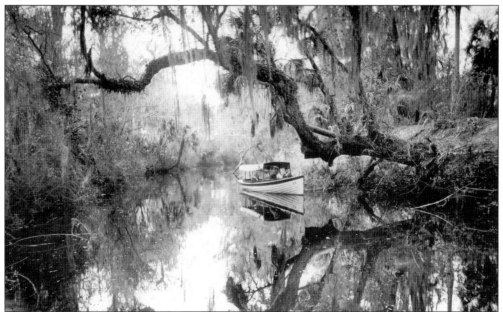

Around 1900, when many dedicated amateurs were beginning to experiment with the camera, the wild beauty of the upper Anclote attracted the talented photographer who made this carefully composed view, which may picture "Dead Man's Tree," one of several legendary sites romanticized by early tour boat captains. This photograph is from an album devoted to Anclote River views made by Spring Boulevard mansion owner George Clemson or a member of the Clemson family.

Several thatched roof pavilions such as this one offered shade and shelter to picnickers and boaters touring the upper Anclote. This shelter was probably at Pinder's Landing, about 10 miles up river from Tarpon Springs, near the towns of Elfers and Holiday. The popular rest stop was on property owned by Thomas Pinder, a Bahamian who was one of the original settlers in the Elfers area.

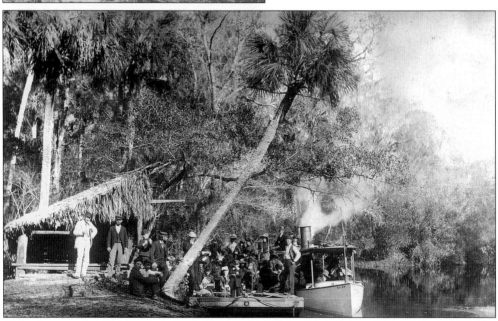

This photograph shows an outing of the Tarpon Boat Club, taken January 31, 1894. Nat Patten's popular steam launch, the *Ellen*, was one of several boats carrying the group up the Anclote. It sits at the dock. The visitors posed for the photographer during a stopover at Pinder's Landing.

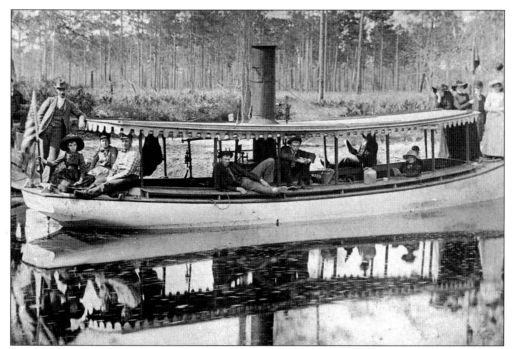

Beginning in the late 1880s, local entrepreneurs built and operated steam launches such as this one to take tourists and winter residents on tours of the Anclote River. By the 1920s, there were five excursions scheduled daily from Tarpon's city dock to Pinder's Landing. The four-hour trip allowed time for "lunching, fishing and looking."

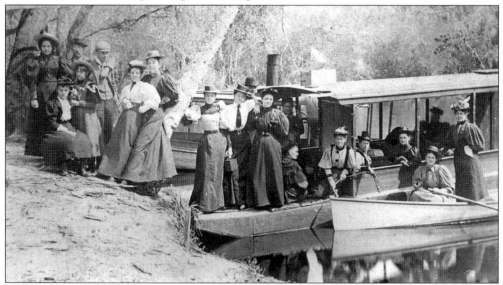

Nathaniel Stone Patten, who established the city's first sawmill in 1884, also built three small steamboats to take sightseeing "pleasure parties" up the Anclote or out to the Gulf. The *Joe*, named after his son, carried passengers and pulled a small houseboat. The *Joe* and the *Ellen*, named after Patten's wife, both appear in this *c.* 1890 photograph. Capt. Jim Turnbaugh, who may have worked for Patten, was in charge of this outing. Patten also offered excursions on his steam launch called the *Natstone*.

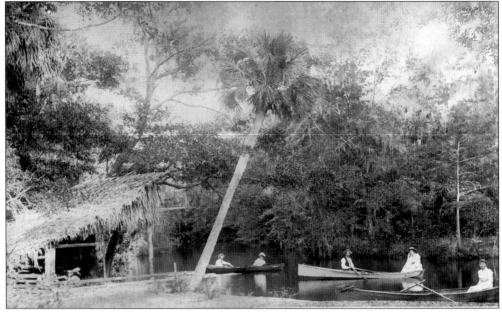

Hoping to enjoy the more serene and romantic aspects of an Anclote River cruise, these couples passed up the noisy steamboat group excursions to tour the river in rowboats. It is likely that the oarsman missing from the boat at the far right stepped out on the shore here at Pinder's Landing to take this photograph.

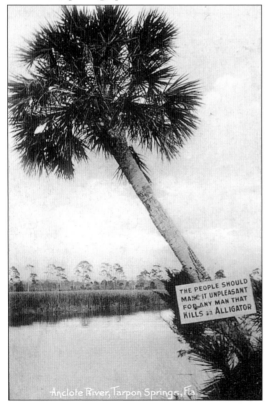

In 1882, a Florida newspaper reported that alligator-hunting tourists "bring big money to Florida every year." As this sign on the Anclote River indicates, one early environmentalist in the area took a dim view of alligator hunting. This c. 1905 photograph was taken for the Clemson family's Anclote River album.

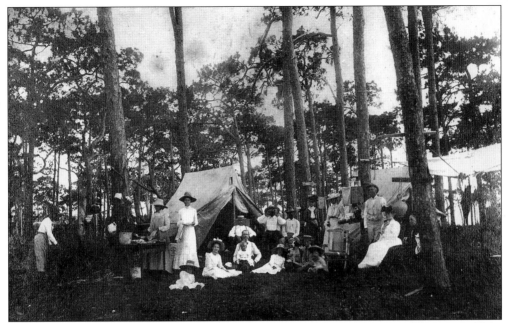

Although it is likely that this 1900 photograph pictures an afternoon picnic, it could be recording a camper's vacation retreat. Camping was enthusiastically promoted in early literature aimed at luring tourists to Florida. For example, Disston's company advertised that "every assistance possible will be given to those who desire to camp at Tarpon Springs; desirable and sightly locations will be cheerfully given Free." In addition, they note, "a good wall tent" can be rented for only a dollar a month.

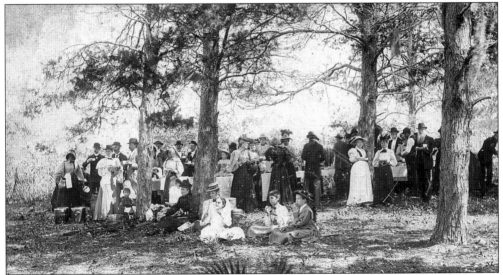

In this picture, the Ladies Bayou Boat Club hosts a picnic at Deserters' Hill, a popular site named for the only event that connects the Anclote area to the Civil War. Local legend has it that in 1864, deserters left Fort Brooke at Tampa and headed to the mouth of the Anclote River to build a bonfire, hoping to attract a federal gunboat. They were captured by Capt. Samuel Hope's Confederate soldiers and hanged on the spot. The site on North Florida Avenue is still called Deserters' Hill.

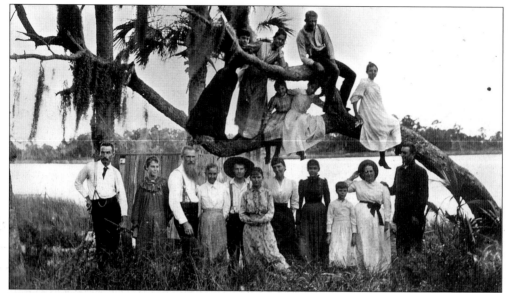

In 1892, when this group gathered for an outing to Port Richey, Tarpon Springs had attracted nearly 500 residents, including several substantial families represented in this photograph. Those pictured here are, from left to right, (standing under tree) John Brown, Maggie Richey, A.M. Richey, Mrs. A.M. Richey, Bill Richey, Anne Richey, Mrs. Sweitzer, Herminia Safford, Mrs. Styles, and Louis Styles; (in tree) Glennie Keeney, Soledad Safford, two unidentified people, Joe Patten, and an unidentified person.

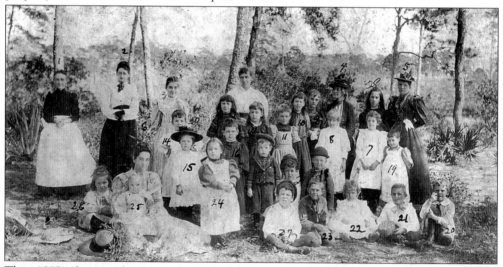

This 1892 photograph pictures Tarpon Springs school students, teachers, and parents. Information written on the photograph is as follows: (1) Rose with Mrs. J.S. Disston (nurse), (2) Lucretia Disston, (3) Lily Styles, (4) Miss. E.J. Sage (kindergarten teacher), (5) Mrs. Weller,(6) Carrie Kirkpatric, nurse to little George Clemson, (7) Ida Weller, (8)Elleenor Morrish, (9) Glennie Keeney, (10) Ruth Davis, (11) Lucy Disston, (12) Mildred Castang, (13) Rose Hartley, (14) Francis Clemson, (15) Marie Disston, (16) Ella Castang, (17) Guy Trueax, (18) Ray Buchanan, (19)Becky Woolf, (20)Hamilton Disston, (21) "lawyer Johnson's boy," (22) Dorothy Disston, (23) Arthur Buchanan, (24) Alice Woolf, (25) George Clemson Jr., and (26) Jennie White.

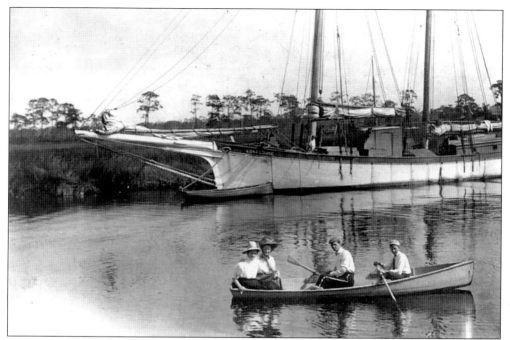

Here, the photographer has captured a group of family friends boating on the Anclote in 1907. They are stopped near the sponge docks in front of the schooner, *Edna Louise*. The young people in the boat are, from left to right, Rose McMullen, who was later married to Sheriff Roy Booth; Iva Albaugh, who married Harold Lenfesty of Tampa; Esten Albaugh; and Clem McMullen.(Courtesy of Rachel Spilman Collection.)

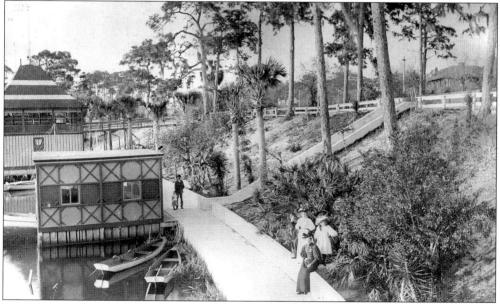

This photograph of families enjoying a walk along Spring Bayou was probably taken in the late 1890s, not long after the city replaced the wooden plank sidewalks and railings that had earlier encircled much of the bayou. The old structures were replaced with concrete walkways, retaining walls, and seawalls sometime around 1896.

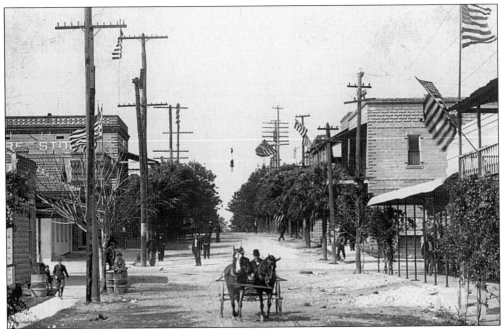

The city's main business district was lined with old and new businesses in 1908, when a photographer took this picture of Dr. A.P. Albaugh driving his buggy down Tarpon Avenue. Tarpon Springs, which had more than 2,000 residents at this date, had grown dramatically since the turn of the century.

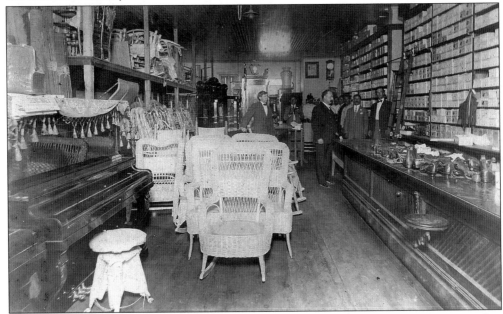

Sometime around 1884, James Vinson moved to Tarpon Springs to open one of the town's first general stores. His brother Levin Denton, known as L.D., joined the business in 1890. This photograph, made after 1900, shows the furniture and shoe display in their store on Tarpon Avenue. They sold clothing and other assorted merchandise in an adjoining department. By this time, L.D. was operating independently, as brother James had returned to Tallahassee.

52

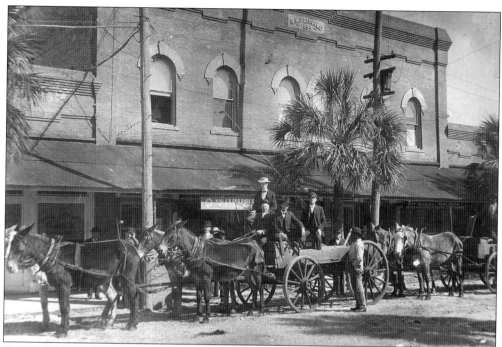

George W. Fernald, one of the city's early pioneers, played an active role in promoting growth and development in Tarpon Springs. In the mid-1880s, he operated a general store, then ran a feed and hardware business. In 1894, he built this two-story building that still stands on the north side of Tarpon Avenue. It is thought to be the first brick building in the city.

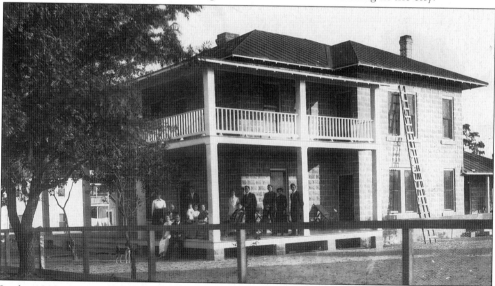

In the 1890s, Vinson's department store sold coffins, along with sewing machines, baby buggies, and pianos. Seeing an opportunity in the town's need for full funeral services, L.D. Vinson went to Atlanta in 1894 to become a certified embalmer. This led to his undertaking business, which he and his family have operated for years in this very building. It still houses their mortuary on East Tarpon Avenue. The Vinson family gathered on the porch for this turn-of-the-century photograph.

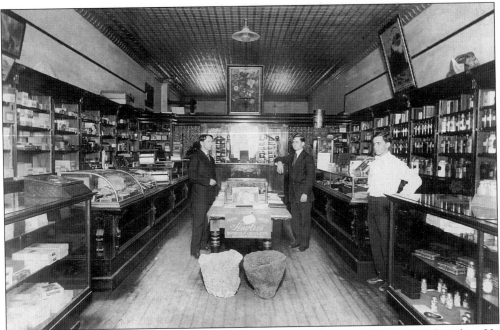

Charles Dix Webster, a paymaster in the Union army, was one of the city's original settlers. He founded this business, the Old Reliable Drug Store on Tarpon Avenue, in 1886. His nephew, Webster Little, eventually took over the business, which operated for nearly 60 years at the same location. This interior view of this long-time local landmark was probably taken about 1905. The young men posing for the picture are, from left to right, Webster Little, John R. West, and John Petzold.

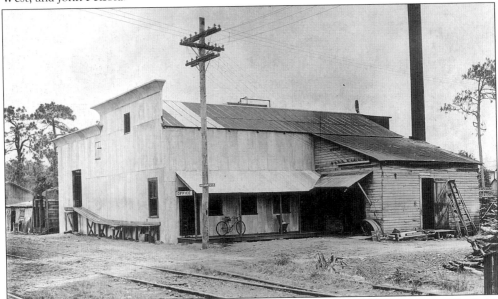

By the turn of the century, Tarpon Springs had its own electric plant and ice factory. The Polar Ice and Light Company shown here was founded and originally operated by George Fernald, Ernest Meres, and Bert Lauden. George Lauden may have been the plant's owner or manager by 1913, when this photograph was taken. The company was located on Orange Street.

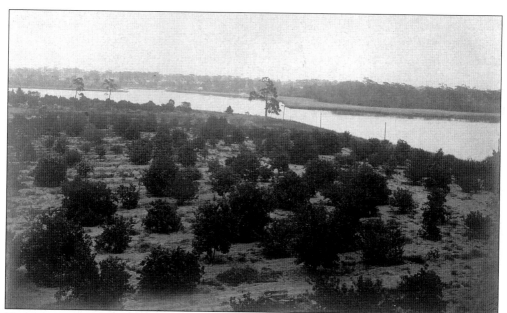

To entice residents and investors to the area, Disston's land company brochures offered glowing reports on "the golden future certain to follow a modest investment in orange groves." By the 1890s, when railroads created a northern citrus market, orange groves were planted throughout the city. The industry spread to outlying areas, such as this property along the Anclote River. In 1914, Tarpon's Board of Trade reported that 2,000 acres of new citrus groves had been planted within five miles of the city.

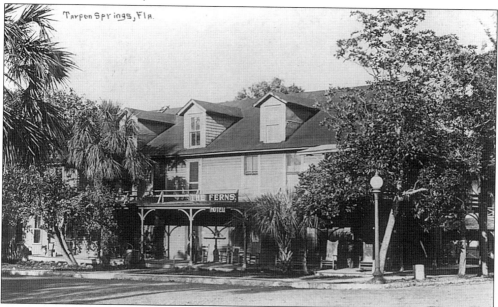

The Ferns Hotel, shown here c. 1920, was the city's longest operating hotel. It was Tarpon's first official hotel, built at the southwest corner of Tarpon and Pinellas Avenues by the Disston development group back in 1883, when it was called The Tropical (see page 22). Sometime in the late 1890s or at the turn of the century, it was substantially remodeled, enlarged, and renamed The Ferns by its long-time proprietor, "Mother" (Amelia) Meres.

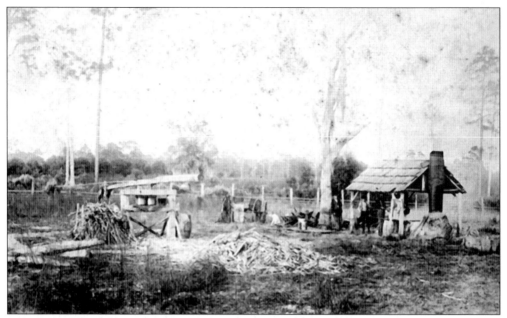

Hamilton Disston and others hoped to make sugar a profitable Florida commodity. Demonstrating its potential, Disston planted 20,000 acres of cane and built large sugar refineries at Kissimee and on Lake Okeechobee. Growing sugarcane for syrup was more widely practiced in Florida by small farmers, who focused largely on local consumption. This cane mill "near Tarpon Springs" may have been near Anclote, where some early settlers experimented with sugarcane. (Courtesy Florida State Archives.)

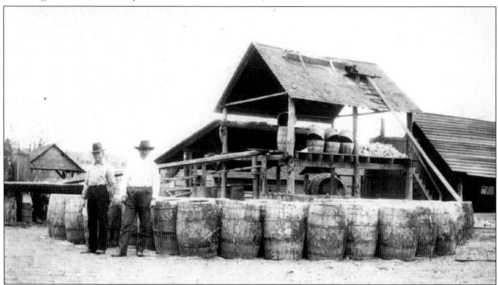

Robert F. Pent, one of Tarpon Springs's early historians, recalled that in "horse and buggy days," he had once taken "a long trip into the country to a turpentine still, where doctors often administered to patients." The unidentified still shown above may have been the site that he visited. Turpentine was used externally for rheumatism, bronchial disorders, and parasites. In the early 1900s, turpentine stills and camps were scattered throughout the region's thick pine forests. (Courtesy Florida State Archives.)

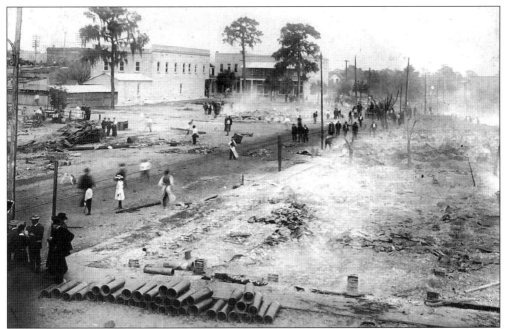

This photograph records the devastation after the fire that destroyed several buildings in downtown Tarpon Springs in 1908. The view looks north up Safford Avenue toward the intersection of Safford and Tarpon Avenues. The railroad tracks cut diagonally across the scene. The pile of rubble to the left in the picture, at the southwest corner of Court and Safford, is what remained of the city's first railroad depot. (Courtesy of Rachel Spilman Collection.)

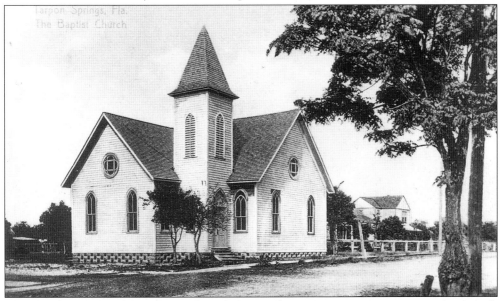

The church-going residents of Tarpon Springs wasted no time in organizing congregations, with two churches established as early as 1886. Baptists first gathered in Anclote in 1892 to form the West Anclote Baptist Church. Their congregation reorganized two years later as the Baptist Church of Tarpon Springs. They built this church in 1909, at the corner of Tarpon Avenue and Ring Street, which they occupied until 1926.

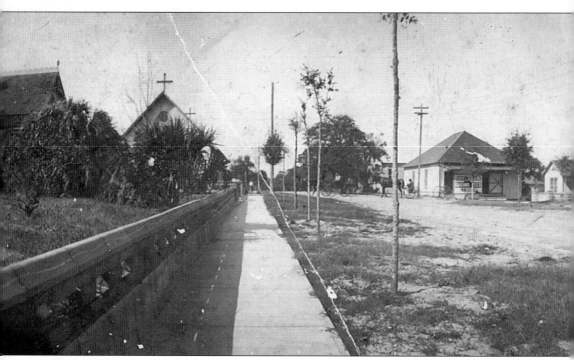

This c. 1908 panorama looks west on Orange Street toward the intersection of Orange and Hibiscus Streets. At the center of the picture stands Trinity Methodist Church, which was built at the intersection in 1902. Across the street, at the opposite corner of Orange and

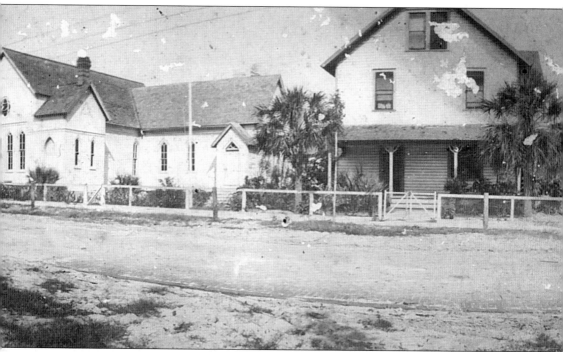

Hibiscus, and on the far left in the picture, is a somewhat obscured view of the city's newly built Greek Church.

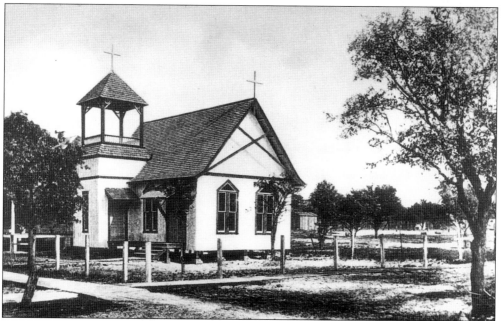

An Episcopal congregation began meeting in Tarpon Springs homes in 1892. Construction on the All Saints Episcopal Church shown here was completed in 1906. In 1979, the church, long known for its beautifully designed windows, was moved from its original downtown location at Grosse Street and Tarpon Avenue to its present site on Keystone Road.

St. Ignatius, the first Catholic Church in Tarpon Springs, was built in 1889 on a lot on West Lemon Street donated by Governor Safford. Safford's Mexican wife, Soledad, was a devout Catholic. The church, originally a tiny chapel, was reportedly named after Mrs. Safford's brother, Ignacio Bonillas. St. Ignacius remained at this site until 1949.

This picture of a St. Ignatius First Communion group was taken about 1910, not long after an addition had doubled the size of the church. Several individuals are identified. Ed Liles (top row, far left) and Marie Liles Tipping (third row down, second from left) are among the young communicants. L.D. Vinson stands at the far left, next to Tom Coburn. Rosa Johnson stands behind the fence, just left of the man standing in front of the fence.

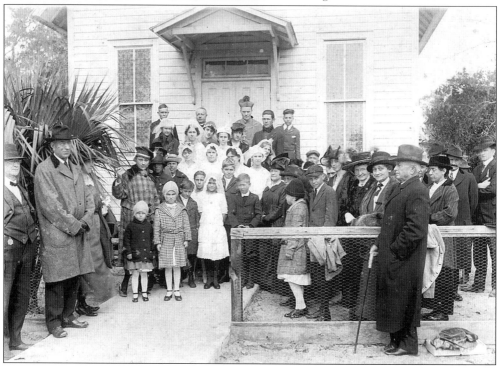

Three

BAILEY'S BLUFF AND THE DEVELOPING SPONGE INDUSTRY

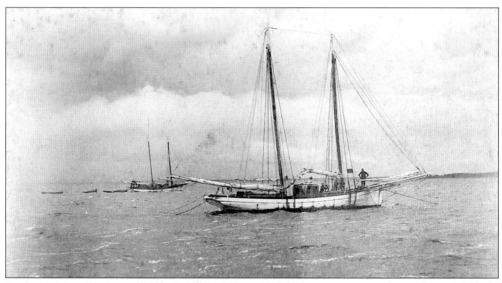

In the1850s, rich sponge beds, equal to those in Mediterranean waters, were discovered near Key West and along Florida's coast. Key West's sponge market flourished as Key West fishermen laid claim to all Gulf Coast sponge beds as far north as Apalachicola. In this 1880s photograph, Key West sponge schooners are moored near the mouth of the Anclote River. Many conflicts occurred when Key West crews faced new competition from Tarpon Springs fishermen.

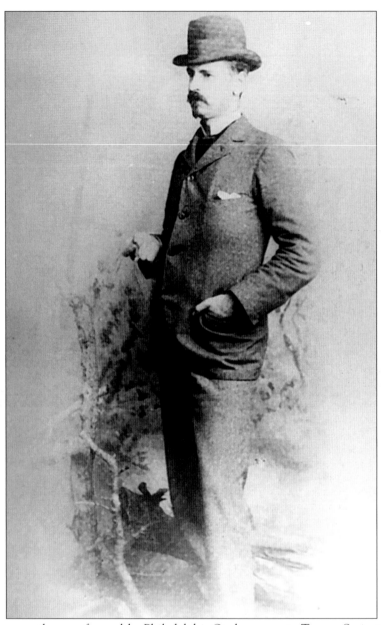

John K. Cheyney, the son of a wealthy Philadelphia Quaker, came to Tarpon Springs in 1886 to oversee his father's financial interests there. When Governor Safford died, Cheyney became head of Lake Butler Villa Company. He soon became interested in the sponge industry that had made Key West the largest city in the state and one of the wealthiest towns per capita in the country. Quickly learning the basics of the business, Cheyney began buying and selling sponges. By 1890, he had built storage kraals at Bailey's Bluff on the coast and a warehouse in Tarpon Springs. He also outfitted the city's first sponge fishing boat. In 1891, with Disston backing, he established the Anclote and Rock Island Sponge Company. By the turn of the century, Cheyney had realized his goal to make Tarpon Springs the center of the sponge industry in America. Through the years, the powerful and respected Cheyney had many business interests that contributed significantly to the economic development of Tarpon Springs.

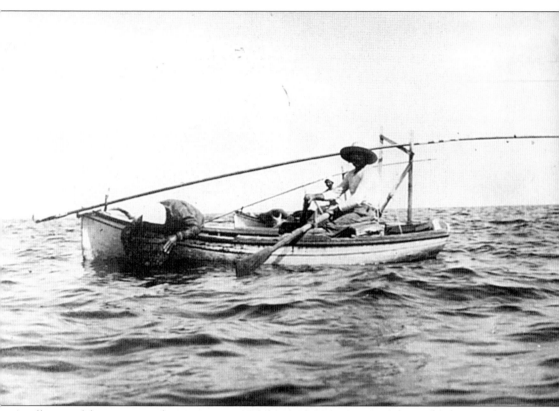

As illustrated here, sponge harvesting was a two-person operation in the early days of the industry in America. Using the age-old "hooking" method, fishermen worked in relatively shallow coastal waters, retrieving sponges with four-prong hooks attached to poles ranging in length from 15 to 40 feet. While one man rowed, the "hooker" searched for sponges by peering into the water through a glass-bottom bucket. In large operations, where voyages lasted weeks, large schooners served as "mother" ships for three or four 12-foot dinghies such as this one. The hook boats remained an important part of the industry locally, even after the introduction of mechanized diving. Hooking is still practiced in shallow waters off coasts in Florida, the Bahamas, and Cuba.

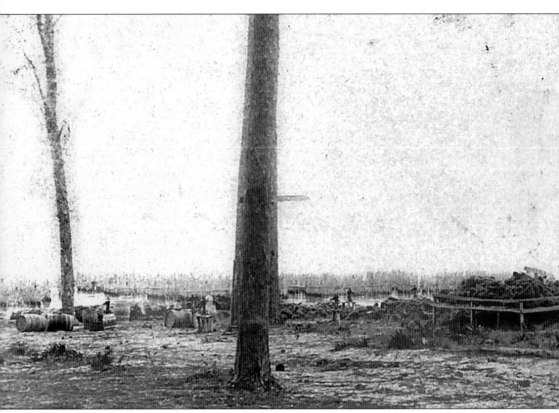

This c. 1900 panorama shows a remote beach area known as Bailey's Bluff, the principal site of John Cheyney's operations. Named after an early Scottish settler in the area, Bailey's Bluff was on the Gulf in Pasco County, just north of the mouth of the Anclote River.

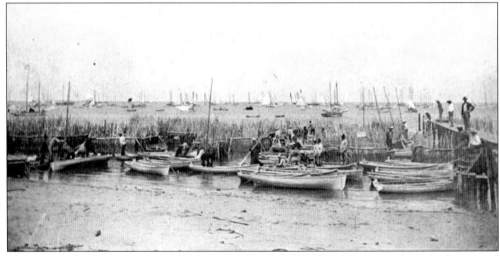

This rare early picture is a unique record of Bailey's Bluff workmen tending the boats and storage pens. The sizeable fleet in the distance supports the reports that by 1898 at least 19 Tarpon Springs fishing boats and nearly 100 from Key West were harvesting sponges off the coast near the Anclote River. Many Key West boats came north at this time to avoid Spanish warships during the Spanish-American War. (Florida State Archives.)

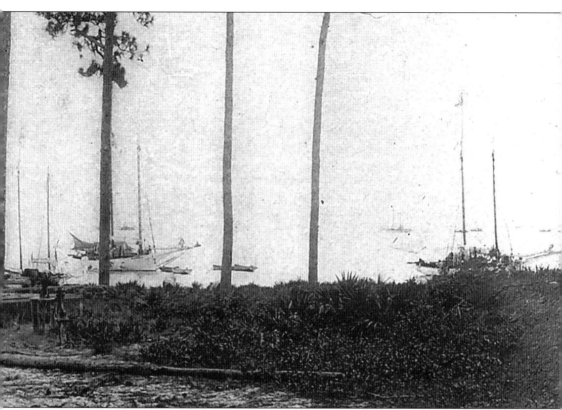

For nearly 15 years, because of Cheyney's efforts in the 1890s, Bailey's Bluff was the center of Florida's mainland sponge industry.

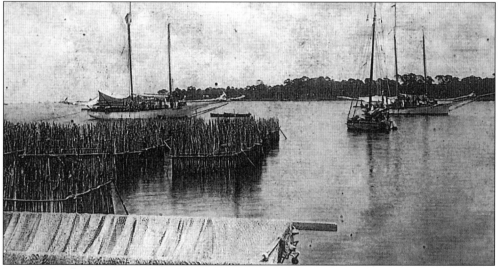

Beyond the drying nets in this photograph are rows of stake-fenced pens, known as kraals, a term derived from an African word for animal pen. Built near the water's edge, these square enclosures stored sponges during part of the cleaning and curing process. For a week or more, sponges contained in the kraals would be alternately washed by the tides, sun-dried, and then beaten with paddles to remove organic matter.

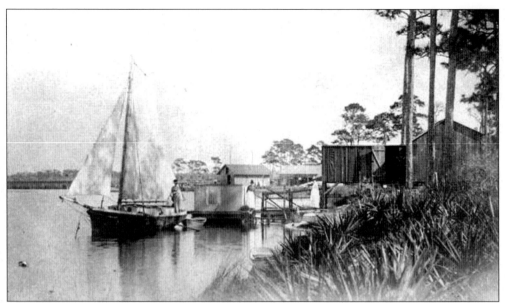

As activity increased at Bailey's Bluff, Sponge Harbor sprang up across the river from the village of Anclote. The tiny settlement, seen in this 1890s photo, was a convenient mooring place for boats working out of Bailey's Bluff. Sponge Harbor had a wharf, boat works, a general store, two packinghouses, and a few cottages occupied primarily by African-American sponge men. Alexis Point is near this location today. (Courtesy Florida State Archives.)

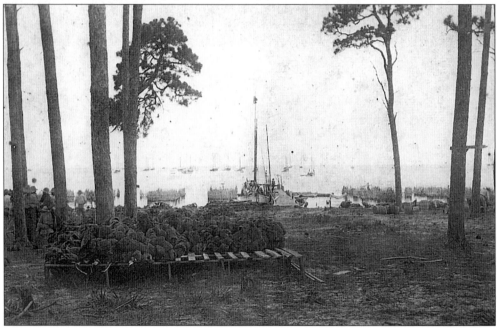

In the early 1890s, John Cheyney leased the Bailey's Bluff property from Samuel Baker of Elfers. Wyatt Meyer took over the lease, built the long wharf seen in this picture, and rented kraals to boat owners. Cabbage Kraals and Union Kraals, sites just south of Bailey's Bluff, were also operating at this time. By the early 1900s, sponge fishing, employing thousands of people statewide, had become Florida's single most valuable fishery resource.

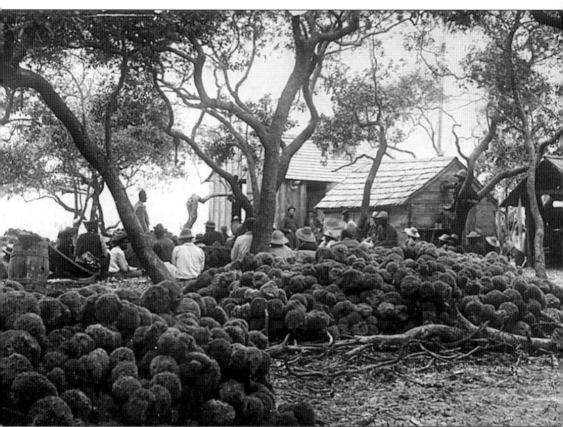

This turn-of-the-century photograph, captioned "Sunday service at the Kraal," shows African-American sponge workers and other locals gathered amidst piles of sponges for an outdoor church service at Bailey's Bluff. Beautiful gospel music and after-church picnics on the beach were traditions long associated with Sundays at the kraals.

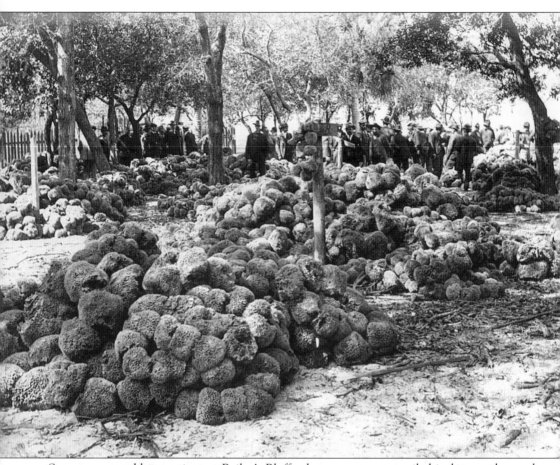

Sponges were sold at auctions at Bailey's Bluff, where sponges were piled in lots on the sandy shore. Although Tarponites John Cheyney and Ernest Meres were the major buyers, they faced increasing competition from other astute locals such as A.P. Beckett, W.W.K. Decker, Bert Louden, Leon Fernald, and Arthur Pinder.

Four

CIVIC PRIDE AND PROGRESS

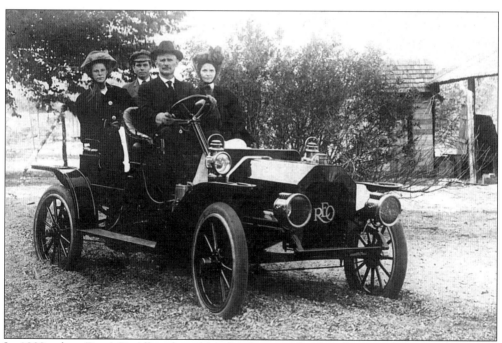

In 1909, when Dr. A.P. Albaugh and his family posed for this photograph, automobiles were still a distinct novelty on the streets of Tarpon Springs. The previous year, Albaugh had enjoyed the distinction of owning the city's first automobile, a Jewel Model D Runabout. After numerous disastrous excursions in the Jewel (all detailed in his diary), he replaced it with this new REO model. (Courtesy of Rachel Spilman Collection.)

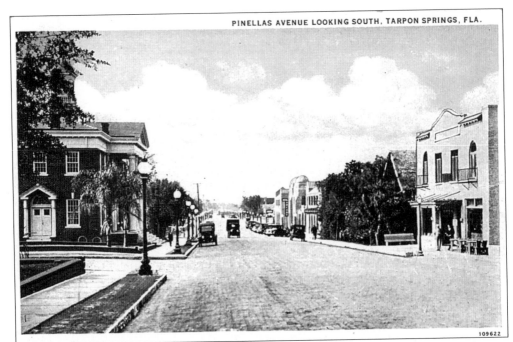

109622

This 1920s postcard view looks south on Pinellas Avenue. The imposing City Hall building on the left sits on Pinellas between Court and Lemon Streets. Across the street from City Hall is a popular tourist attraction of the time—the vine-covered house known as Cherokee Cottage. The newly built Arcade Building can be seen on the corner beyond Cherokee Cottage.

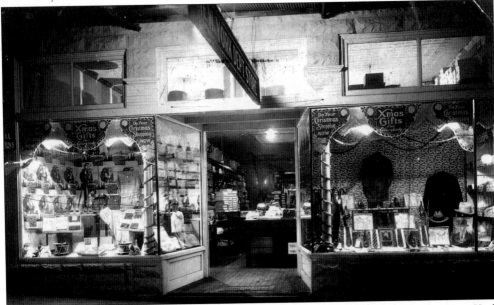

Abe Tarapani came to Tarpon Springs from New York City in 1911 to open the New York Bargain Store on Safford Street. He created this Christmas window display in 1922, when he moved his business to Tarpon Avenue. In 1931, he sold men's overalls for 86¢. In 1935, he renamed his enterprise Tarapani's Department Store and moved it across the street to 128 East Tarpon Avenue, where it still operates today.

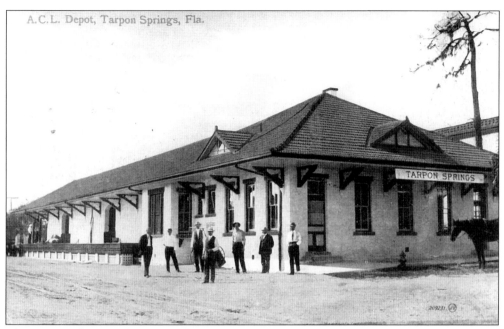

This *c.* 1913 photograph pictures the new Atlantic Coast Line Railroad depot, built in 1909 at the corner of Tarpon and Safford Avenues. The old depot burned in 1908. Passenger service to Tarpon was discontinued in 1971. The rail line is now the Pinellas Trail. Today, the old depot building houses the Tarpon Springs Area Historical Society.

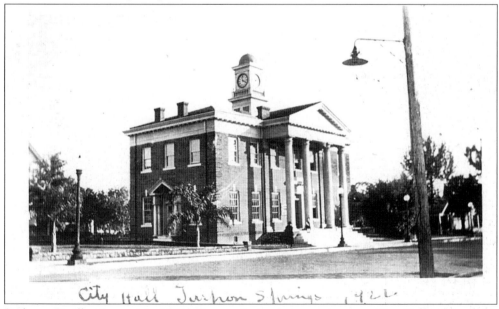

Built on Pinellas Avenue in 1914, Tarpon Springs's impressive new City Hall reflected the community's growing confidence in its potential for growth and progress in the new century. When this photograph was taken in 1922, City Hall housed the public library in addition to government offices. The police and fire departments were also located in the imposing Greek-Revival–style building. When municipal offices moved in 1987, the old City Hall became the Tarpon Springs Cultural Center.

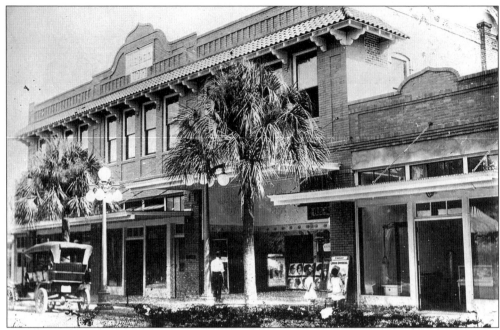

The Meres Building on Tarpon Avenue was an impressive new addition to the city's growing business district in 1914. Its owner, Ernest Meres, whose parents were among the city's pioneer founders, was a successful sponge merchant and businessman. He was co-founder with John Cheyney of the Sponge Exchange in 1907. The Meres Building, which still stands, housed various businesses through the years, including the Greek American Bank and one of the city's first movie theatres.

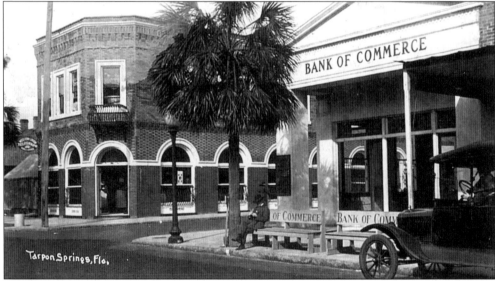

The Sponge Exchange Bank, established in 1906, was the first state-chartered bank in Tarpon Springs. A rival enterprise, called the Greek American Bank, was chartered in 1911. In 1918, the Greek American Bank was renamed the Bank of Commerce and moved from the Meres Building on Tarpon Avenue to this site at the corner of Tarpon and Hibiscus Street. This photograph was taken about the time of the bank's relocation.

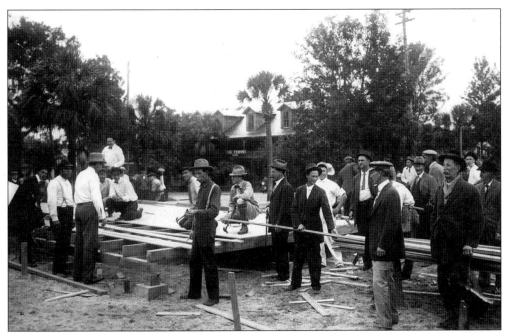

In the early years of the century, Tarpon Springs's civic leaders actively pursued new opportunities for commercial development. The construction of a new Board of Trade building in 1915 was part of that effort. This photograph shows some of the 100 volunteers who pitched in to erect the structure in a one-day communal effort. The new building was on Citron Street (now Pinellas Avenue), a block south of City Hall.

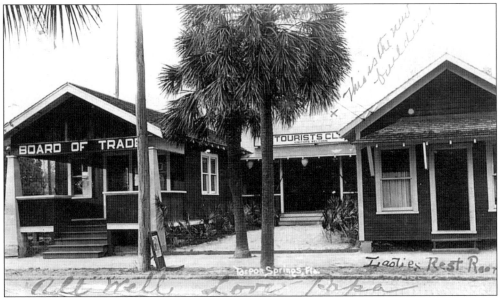

This *c.* 1920 photo shows the Board of Trade office and the Civic Club's new "Rest Room" facility, a hospitality lounge for female tourists. Another new building on Citron Street, seen at the center of the picture, housed the Tourists' Club, founded in 1918 by Dr. William Morgan. During the 1920s, the Tourist Club, with ongoing programs and parties, was a vital part of the social scene for both seasonal and year-round residents.

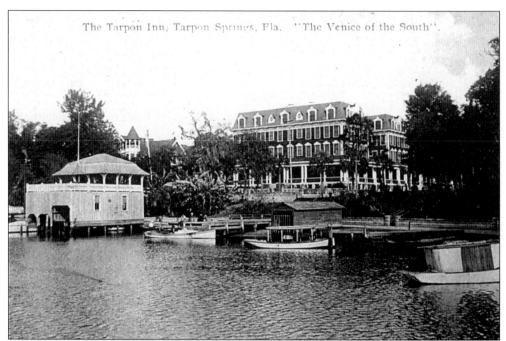

The city's famous Tarpon Inn was built in 1912 at a cost of $150,000. The 100-room hotel featured such amenities as steam heat and telephones in every room. As suggested in this 1920s photograph, the inn's prime location at the end of Tarpon Avenue provided guests with a beautiful view of Spring Bayou. This photograph shows the city pier at center and the hotel's popular two-story boathouse.

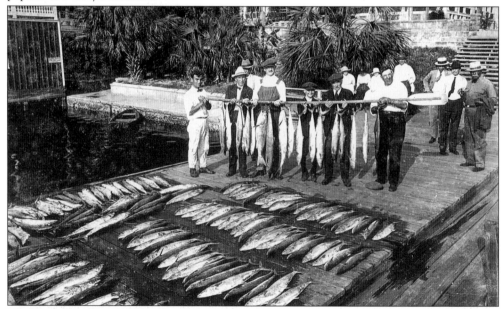

The Tarpon Inn was well known for catering to its many fishermen guests, who were routinely seen posing for photographs with their catch and the inn in the background. In this case, making an appropriate record of this impressive display of kingfish called for the talents of local professional Hayes Bigelow, who made this photograph in 1922.

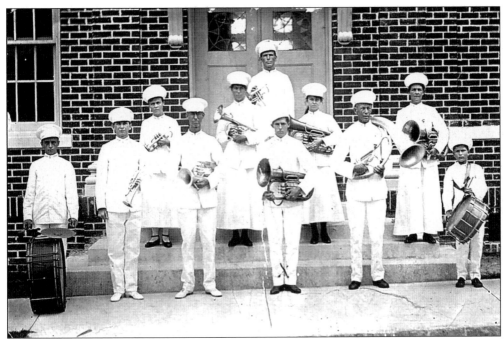

Tarpon Springs's Citizen's Band added an appropriate spirit of pomp and circumstance to many public events during the teens and 1920s. Band members shown in this *c.* 1917 photo are, from left to right, (first row) Willie Perenis, Levin K. Vinson, W.W. Martin, Dan Smith, Louis Styles, and Gale Riegel; (second row) Camelia Smith, Ida Mae Smith, Melvean Smith, and Mrs. Cynthia Eugene Smith; (top row) J.D. Smith.

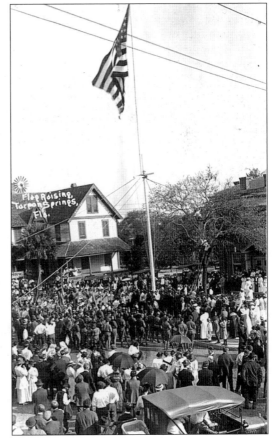

During World War I, citizens took part in many patriotic events and activities aimed at war preparedness. In this photograph, taken in 1916, throngs of Tarponites gathered to see the newly erected flagpole and applaud the first flag raising. The building in the distance is the Topliff family's boarding house, which was located where First Federal Savings and Loan Association stands today.

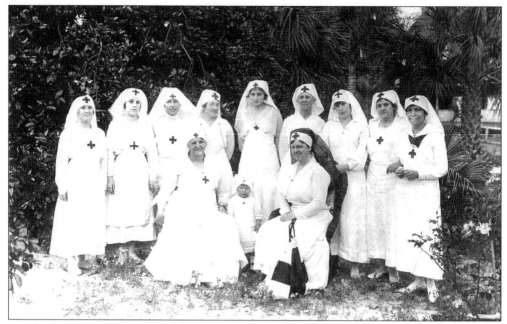

Local volunteer groups such as this one in Tarpon Springs helped transform the American Red Cross into a powerful social force during World War I. Before the war, the Red Cross had 562 chapters and 500,000 members. By the end of the war, there were more than 3,700 local chapters and 31 million volunteer members. This photo, taken in 1918, pictures local Red Cross volunteers who completed the Surgical Dressing Class.

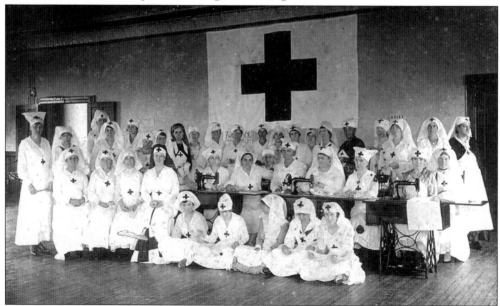

During World War I, Red Cross volunteers provided valuable assistance by making much-needed relief articles for troops abroad. In addition to surgical dressings, their production included sewn and knitted garments and "comfort kits," which were small bags typically containing razors, cigarettes, chocolate, toothpaste, writing paper, and books. This 1918 photo shows Tarpon Springs sewing volunteers in their Red Cross Chapter Workroom.

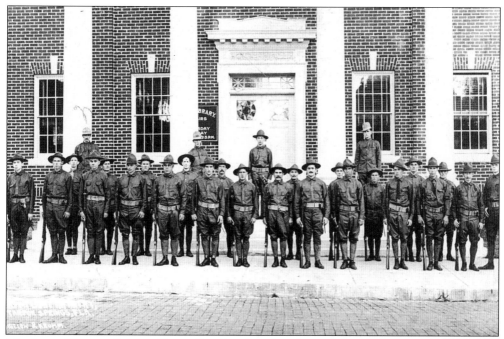

Members of Tarpon Springs Home Guard gathered in front of City Hall in 1917 to have this photograph taken by local photographer Hayes Bigelow. During the war, Tarpon's guard unit took part in countywide maneuvers. Guard members were trained and drilled by commanders Capt. Harold Loomis and Capt. Esten Albaugh.

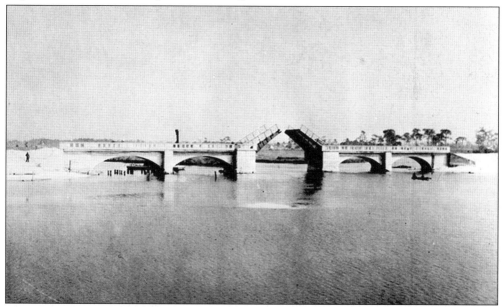

The first bridge over the Anclote River was at the foot of Huey Avenue. By the late 1880s, there was a narrow wooden bridge spanning the river at the foot of Athens Street. In 1917, the county constructed this new reinforced concrete drawbridge on what is now Highway 19A. This photograph was taken shortly after the new bridge was completed. The existing bridge at this location was built in 1956. (Courtesy Florida State Archives.)

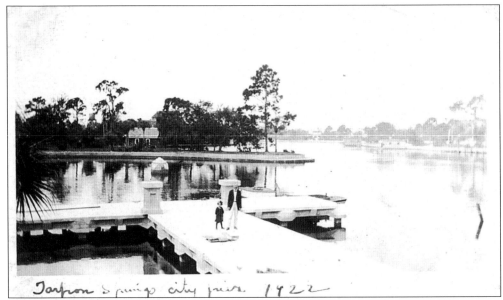

Tarpon Springs city pier 1922

A new city pier was another measure of 20th-century progress in Tarpon Springs. This c.1922 photograph shows the new, enlarged, modern-looking concrete structure that replaced the old wooden dock built back in the 1880s. Looking beyond the pier across the water, we see the base of the Spring Bayou fountain and the Keeney-Beekman house on the opposite shore.

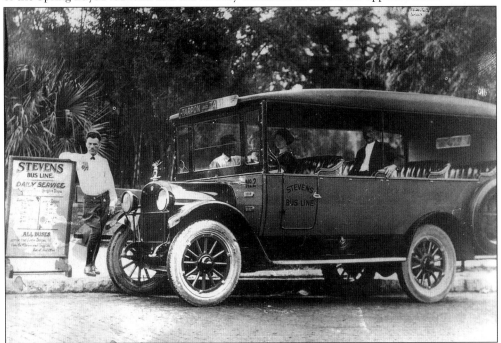

As more tourists headed for Florida in the 1920s, new businesses sprang up to meet their needs. Stevens's Jitney Line was one of the new tourist services. Stevens's 16-passenger buses such as this one made two trips daily from Tarpon Springs to Tampa, with stops in between at Wall Springs, Sutherland, and Oldsmar. Visitors and businessmen could also take a Stevens jitney from downtown Tarpon to the Sponge Docks.

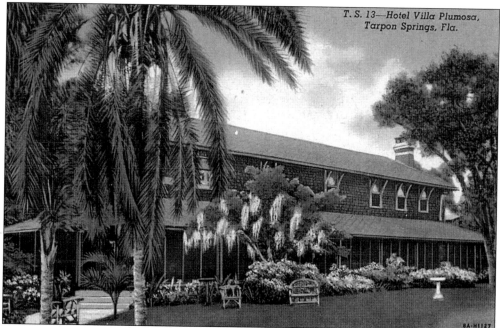

In the 1930s, this picturesque cypress-shingled hotel called the Villa Plumosa was a favorite with wealthy winter visitors. Originally an elegant private home, it was converted to a hotel in the 1920s. In addition to its romantic tropical gardens, it was known for outstanding cuisine, home-style comfort, and fresh oranges in every room. The hotel stood at the corner of Spring Boulevard and Orange Street, where the Villa Plumosa Condos are today.

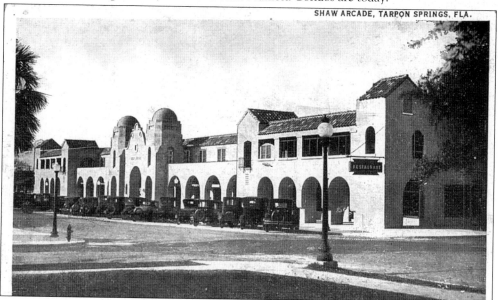

SHAW ARCADE, TARPON SPRINGS, FLA.

During the Florida real estate boom in the 1920s, business leaders were eager to expand the city's commercial district onto Pinellas Avenue. The grand new Arcade Hotel, costing $100,000 in 1925, was an ambitious step toward that goal. The fashionable Mission Revival—style building was extremely modern in its multi-purpose concept—the upper story was a hotel, while the lower level was designed for shopping.

79

GOLDEN GATE OF THE WEST COAST

TARPON SPRINGS
FLORIDA

"CITY OF PICTURES"

TARPON SPRINGS
FLORIDA

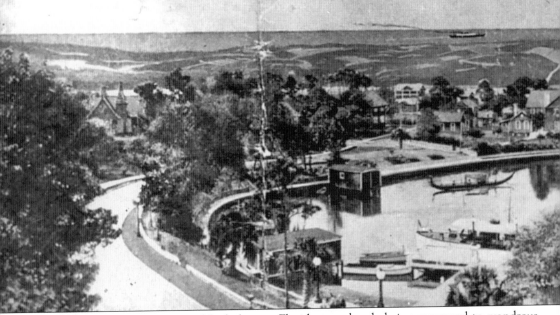

By 1850, the then remote and little-known Florida was already being compared to wondrous Italy, 19th-century America's dream-vacation land. According to one early Florida enthusiast, with Florida more accessible, there would no longer be any need for Americans "to visit Italy . . . for the improvement of their health as our climate is equally salubrious." Florida boosters drew similar parallels between Italy and Florida's scenic terrains. Proposed connections between Tarpon Springs and the beauties of Italy were even more specific. In 1896, a book promoting the Gulf Coast area called Tarpon Springs "The Florence of the Pinellas Peninsula." By the turn of the century, local promoters, thinking along similar lines, were plugging a more

TARPON SPRINGS
FLORIDA

The Venice of the South

HIGH ELEVATION · BAYOUS · BAYS · LAKES · RIVER · AND GULF OF MEXICO

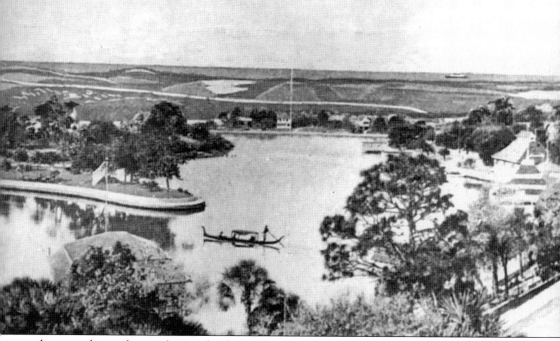

enduring and appealing nickname for their city—the "Venice of the South." This cover from a 1926 Chamber of Commerce promotional brochure underscores that theme. Like Venice, Tarpon Springs, with its 35 miles of shoreline, was a town distinguished by picturesque waterways. To promote that connection, the city purchased two Venice-style gondolas from the Sesquicentennial Exposition in Philadelphia. This sweeping vista, which looks all the way to the Gulf, shows the two gondolas on Spring Bayou flanking the surging jet of water from the bayou's much-admired fountain.

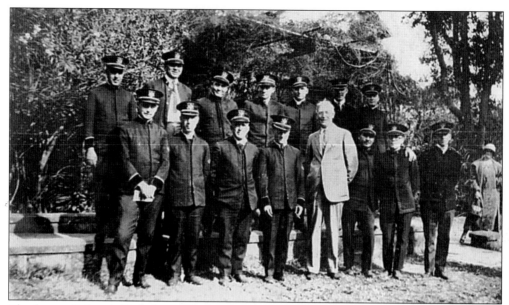

The famous Bohamir Kryl, shown here with several of his band members, helped make Tarpon Springs a well-known cultural center during the 1920s. During the winter months, Kryl and his musicians performed free daily concerts to record crowds at the city park band shell on the corner of Pinellas and Tarpon Avenues. Kryl's band, apparently hired by the city, was so popular that he reportedly received $40,000 for the season.

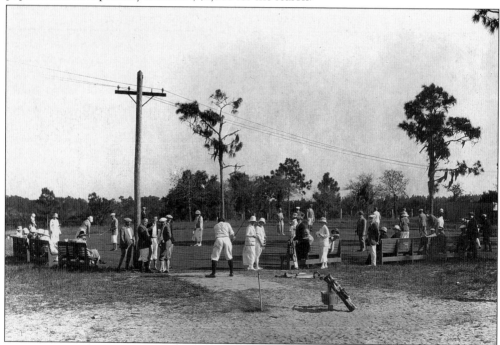

"Putting parties" such as this one were especially popular with female winter residents, although men are also participating in the 1930s event shown here. A privately owned nine-hole golf course, one of the earliest in the state, opened in Tarpon Springs in 1907. The city bought and expanded that course in 1927. The city's public course still operates on that property.

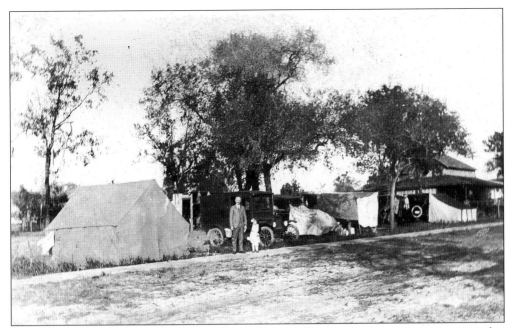

Automobiles and new road building programs dramatically increased tourism in America after World War I. Exotic Florida was one of the most popular destinations for vacationing motorists. In the days before motels, when lodgings were scarce and expensive, thousands of visitors to Florida came with tents and blankets. This snapshot portrays two of the hundreds of winter visitors who came by car to pitch tents on the outskirts of Tarpon Springs in 1924.

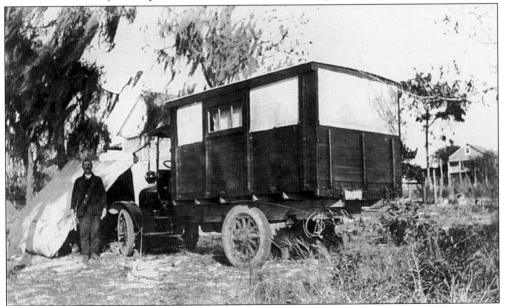

This 1920s snapshot inscribed "Canada House Car" shows an ingenious Canadian tourist who was decades ahead of his time with his makeshift travel trailer. He is camped at a free campground in Tarpon Springs. During the 1920s, "free camps" filled with "tin can tourists" appeared all over Florida. Northerners who came south for the winter in cars loaded with tents, bedding, and canned goods came to be called "tin can tourists."

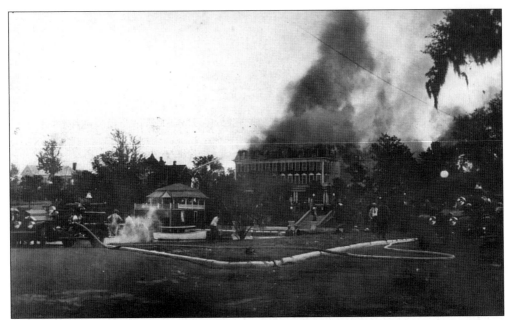

On the morning of March 4, 1927, the Tarpon Inn burned to the ground. Although firefighters arrived early on the scene, they could not contain the blaze. The cause of the fire was never determined. The Tarpon Inn was located on the present site of the Gondolier Motel. New owners of the Gondolier recently changed the name of the motel to The Tarpon Inn.

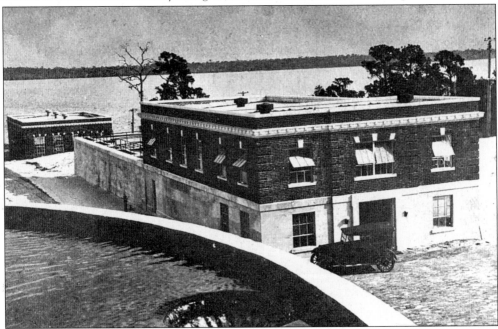

In 1925, Tarpon Springs spent a half-million dollars constructing this new municipal water plant on Lake Tarpon. The project proved to be a costly mistake. The plant was shut down in the late 1920s (and never reopened) when it was learned that salt water was seeping into the lake. In later years, a cofferdam was constructed to seal off subterranean connections between the lake and Spring Bayou that had caused the salt-water intrusions.

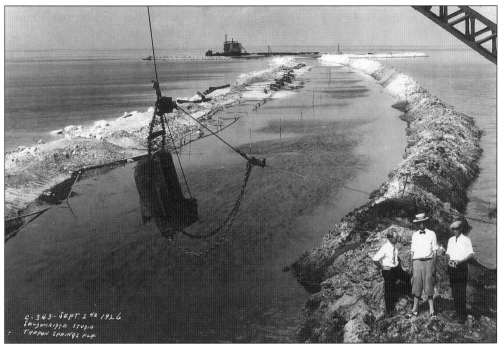

City planners were thrilled when construction began in 1926 on "a pier"—actually a causeway—to enhance the city's favorite recreational spot on the Gulf (now Sunset Beach). At this stage of the project, workers have constructed the dike to contain the fill for support of the causeway superstructure. The boom of the crane in the foreground, with the dragline and bucket attached, was used in the construction process.

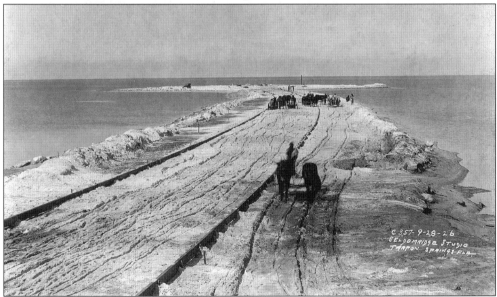

Workers on the causeway were pressured to complete the project by November 1926, when the city had scheduled a large American Legion Convention. At this point in the construction, workers had installed fill material and put down cypress curbing inside the dike structure. Workers with mules and early grading equipment are shown leveling the surface.

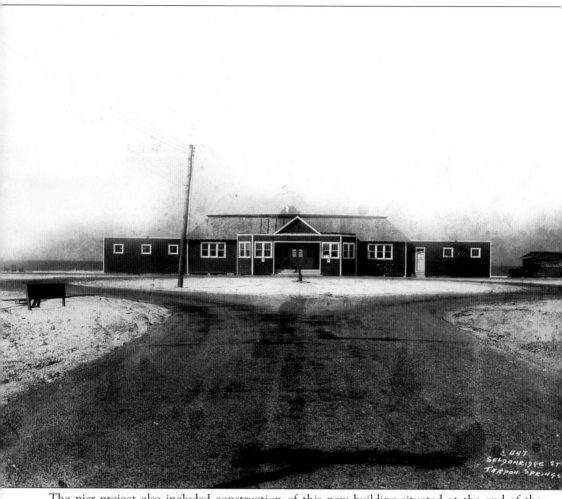

The pier project also included construction of this new building situated at the end of the causeway, which offered refreshments, dressing rooms, and other services for bathers and visitors to the pier. It housed its first event, the American Legion Convention, in November 1926. For 35 years, the pavilion was used for dances, receptions, public dinners, and meetings. The facility was newly remodeled when it burned in 1964.

Five

THE SPONGE CAPITAL
OF THE WORLD

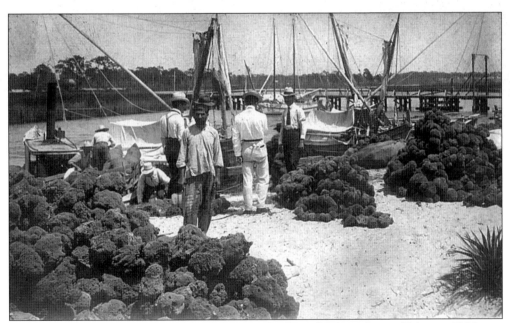

This scene shows the Anclote River banks near the foot of Athens Street. Taken *c.* 1906, it is an unusually candid record for its time of the newly developing sponge business in Tarpon Springs. The sponges piled on the beach were probably transported from Bailey's Bluff or Sponge Harbor. The wooden bridge in the distance once crossed over the Anclote at the foot of Athens Street.

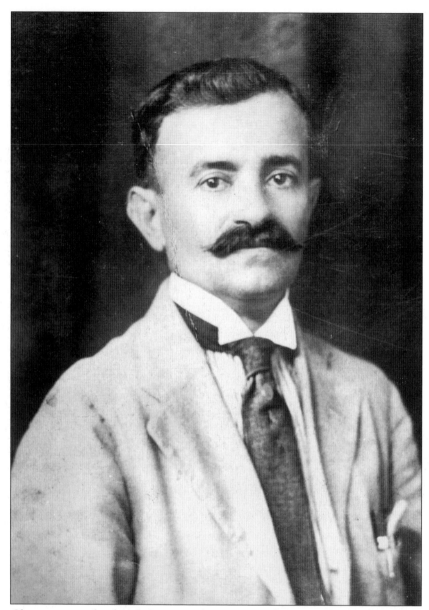

If John Cheyney is credited with bringing the sponge industry to Tarpon Springs, this man, John M. Cocoris, was in large part responsible for expanding that industry into a worldwide operation. The young Greek sponge buyer came to America in 1895 to work in Florida for a New York dealer. Cocoris worked at Key West before joining John Cheyney's Tarpon Springs's operation as a buyer and technical consultant. Cheyney agreed to hire Cocoris's three brothers, as well. In early 1902, Cocoris moved with his family to Tarpon Springs, where his new wife Anna was the first Greek woman in the city. In their free time, the brothers harvested and sold sponges. John soon realized that the area offered immensely rich sponge beds that lay beyond the reach of the sponge hook. He convinced John Cheyney that they could mine this rich untapped resource with Greek divers and diving equipment. With Cheyney's financial support and Cocoris's connections, they brought the first team of Greek divers to Tarpon Springs in the summer of 1905.

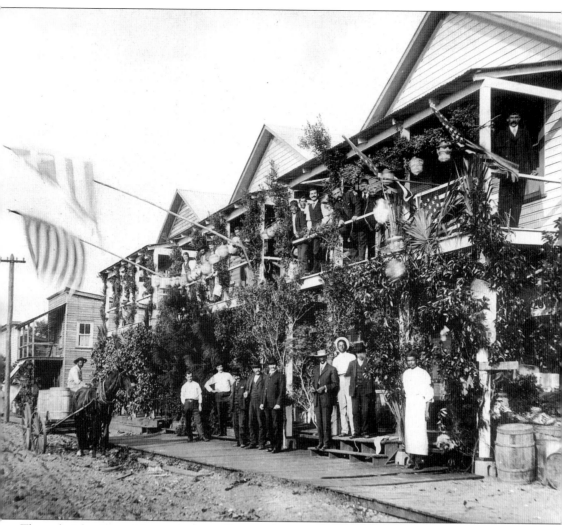

Through John Cocoris's recruitment efforts and reports in Greek language newspapers, news of Tarpon Springs's growing sponge industry spread rapidly abroad. By late summer 1905, some 500 Greek men were living in the city. In addition to divers and sponge crews, the new immigrant community included dealers, processors, warehouse workers, boat builders, mechanics, and financiers. They all came initially without their families. Only the most affluent of the newcomers would be staying at this Greek-run boarding house. In the early years, some of the Greek fishermen lived on boats and others lived together near the waterfront in crude makeshift barracks, cooking and washing outdoors.

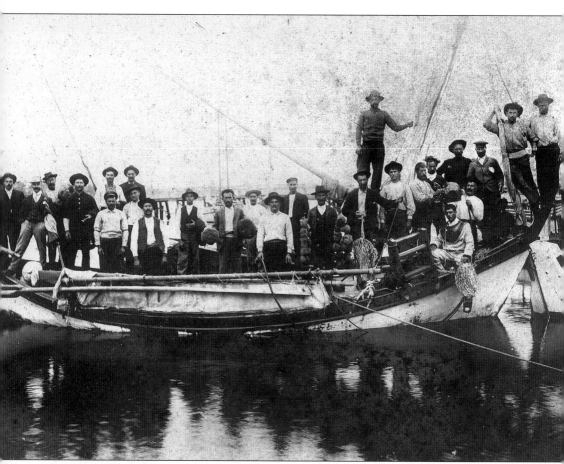

Taken sometime around 1907, this carefully posed photograph was made by C.C. Allen, a professional photographer from St. Petersburg. It appears to be a formal group portrait, which suggests some connection among the nearly 30 men posing for the picture. It is possible that the men gathered here were from the same town or island in Greece. To families back home, copies of this photo would have been comforting evidence that their distant loved ones were surviving and surrounded by friends. The early Greek immigrants came primarily from the islands of the Aegean Sea, with many coming from the Dodecanese islands of Kalymnos, Halki, Symi, Hydra, Spetse, and Aegena, which are famous for producing the best sponge fishermen in the world. In the 1920s Tarpon Springs honored this aspect of Greek heritage by changing the name of Anclote Boulevard, the street running alongside the sponge docks, to Dodecanese Boulevard.

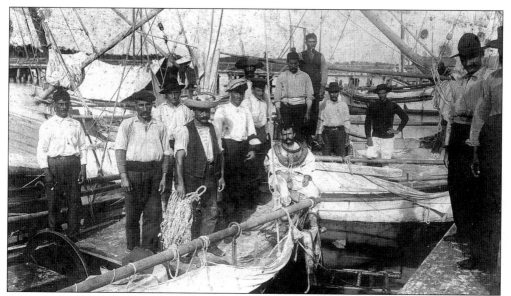

An early diving boat crew gathers here to pose for St. Petersburg photographer C.C. Allen. Typically numbering five to six men, crews such as this one were paid by the traditional Greek share system. A trip's catch was sold at auction. Money earned from the catch, after overhead, was divided into shares that were distributed based on skills and seniority. For example, if a deckhand received one share, the diver would likely receive four.

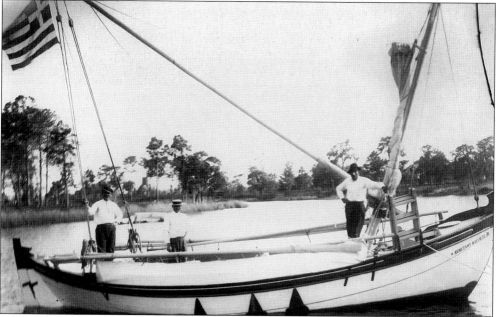

Expressing the Greek fisherman's enduring attachment to his homeland, Greek flags, such as the one flying here, became a common sight on the Anclote River. Greek boat captains created another reminder of home when they followed the Mediterranean tradition of brightly painted sponge boats. Many of the boats were blue and white, the colors of the Greek flag. The dark triangular shapes accenting the sides of many sponge boats were both decorative and functional. Their dark color helped to conceal the dirty runoff from drainage holes.

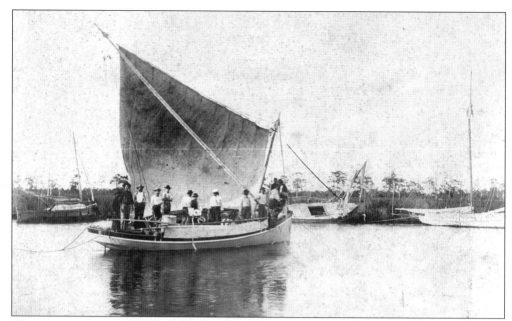

This early hook boat under sail on the Anclote River displays the distinctive lateen sail that became the hallmark of the Greek fishing vessels that first worked Florida's Gulf Coast waters. Used for centuries by Mediterranean fishing boats, these triangular fore-and-aft sails were set at an angle to a low mast. The lateen rig was considered superior to the square sail for sailing into the wind. Northern Europeans sailing on Mediterranean seas named the sails after the word "Latin."

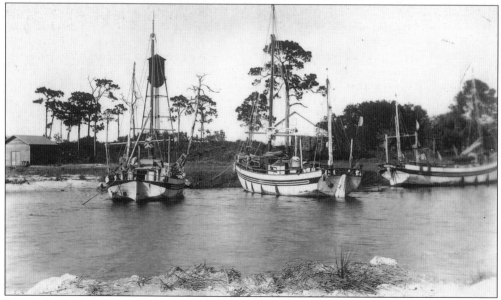

Diving boats moored up and down the banks of the Anclote reflected the steadily growing sponge business. Some of the early diving boats were old fishing sloops remodeled by Greek carpenters and outfitted with air pumps and hoses. Sloops were sometimes converted into "double-enders," which were used for centuries by Mediterranean fishermen. A double-ender, with a stern as wide as its bow, provided space for additional fuel needed for longer voyages.

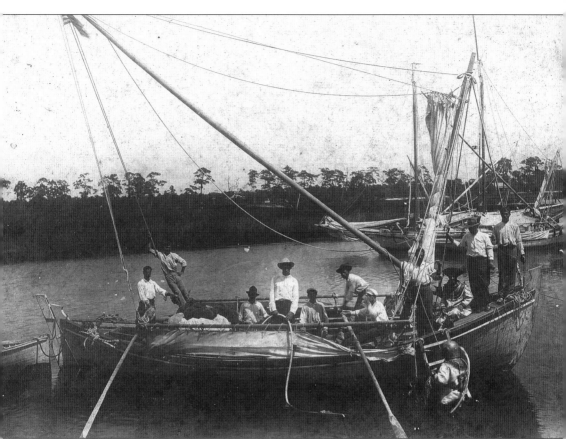

In this scene staged for the photographer, the boat's diver has donned his gear to climb down the ladder. As the photographer intended, the rubber air hose attached to the diver's helmet is clearly visible. The all-important "life-line tender" stands at the center of the boat, hoisting his end of the air hose. From deep in the water, the diver communicated to the tender above by tugging on the line to convey various signals. In the very early days of mechanical diving, spongers on deck turned the wheel of a hand-operated air pump from morning to night to supply the diver below with air. Typically, the diver remained on the ocean floor for two-hour periods. Despite the financial success of diving boats like this one, the highly competitive Key West spongers never took up the practice. Indeed, the enduring tension that developed between Key West hook fishermen and Tarpon's diving crews sometimes erupted into violence.

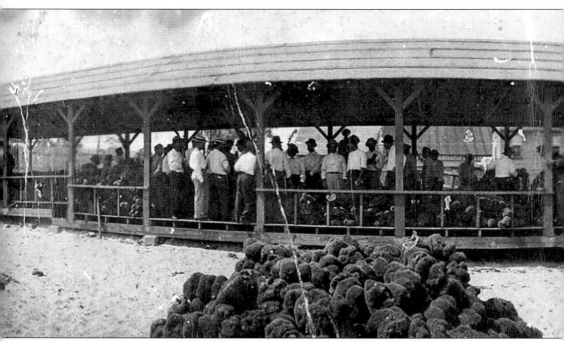

By 1907, spongemen began bypassing Bailey's Bluff to deposit their catch at sites along the riverfront near the Athens Street bridge. The founding of the Sponge Exchange by John Cheyney and Ernest Meres in 1907 was instrumental in moving the action from the coast to the city's riverfront. Their new Sponge Exchange, a non-profit shareholding company, was organized to regulate procedures related to sponge sales. The Sponge Exchange also built and operated this large facility, providing secure storage cubicles for each captain, covered inspection areas, and a site for twice-weekly auctions. In the

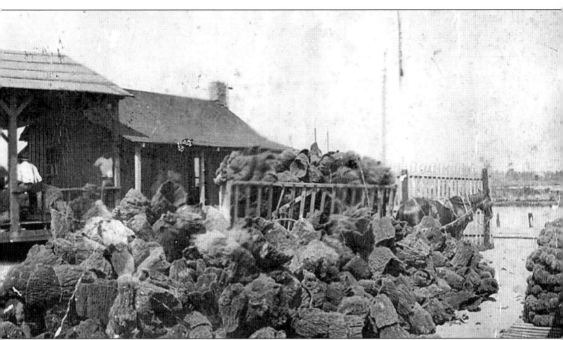

foreground here, sponges are piled up for inspection in the fenced yard adjoining the new Sponge Exchange building. An auction may be in progress under the pavilion. All buyers and sellers were required to contribute a percentage of the purchase price to help maintain the exchange. As this prosperous marketplace attracted more boats and dealers to the area, the industry spread out around the waterfront as warehouses, suppliers, boat works, and other related businesses sprang up to meet the industry's growing needs.

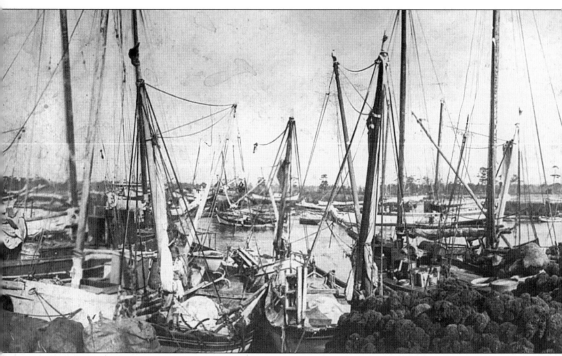

Taken before docks or piers were common, this wonderful panoramic photograph of Tarpon's riverfront is among the earliest known visual records of the strip of shoreline now called the sponge docks. The crowded chaotic nature of the scene confirms that the area was already a

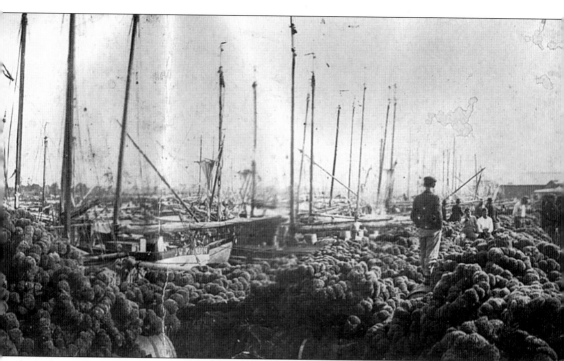

bustling center of business activity. In haphazard fashion, boats are anchored at will; others pulled at odd angles onto the sandy banks on both sides of the river. Diving boats, hook boats, and schooners competed for space in the crowded harbor.

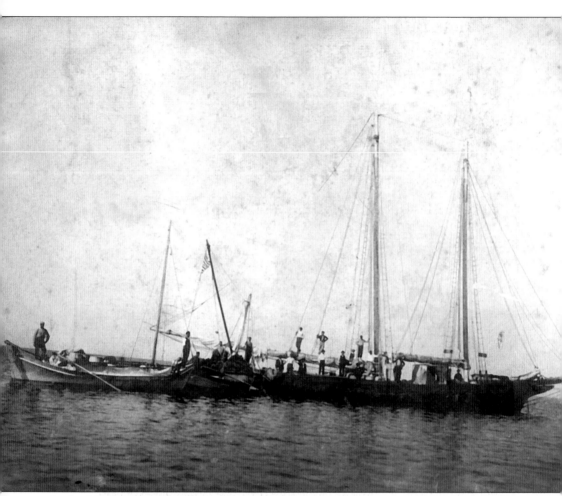

In the 1910s and 1920s, large schooners such as this one served as "depositories" for fleets of several smaller diving or hook boats. Each evening, after a long day spent fishing in distant waters, the fishing boats regrouped to anchor near the schooner. The day's harvest was transferred to the deck of the "mother schooner," where the sponges would be cleaned and dried. The sponge boat crews slept and ate aboard the larger vessel. Their evenings were spent pounding and cleaning the day's catch or stripping away membranes from sponges collected earlier. It was not an easy life. In addition, in the early years, crews typically remained at sea for five-to-six-month periods. During these long voyages, messenger boats visited the schooner at three-to-four week intervals to retrieve the sponges and deliver mail and fresh bread and water to the crews.

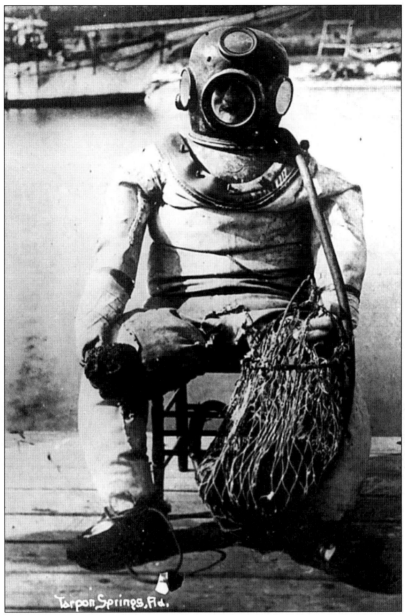

Tarpon Springs, Fla.

This diver wears the equipment that revolutionized the sponge industry in Tarpon Springs, just as it had in the Greek Islands. The diving suit, known as a skafandro to Greek fisherman, was developed in 1885 and in common use by Greek divers in the 1890s. The revolutionary gear consisted of a rubberized diving suit fitted with a bronze collar and a heavy bronze detachable helmet with a small glass window. The helmet was equipped with a valve for the air supply. The air supply, furnished by a pump installation on deck, traveled to the helmet through a rubber hose that was reinforced with steel wires. The divers also wore shoes and belts weighted with metal. In full gear, they hit the water weighing close to 400 pounds. With the new equipment, divers could descend to much greater depths and stay on the ocean floor for much longer periods of time. It was estimated that in the same amount of time, a diver could collect four times as much sponge as an accomplished hook fisherman.

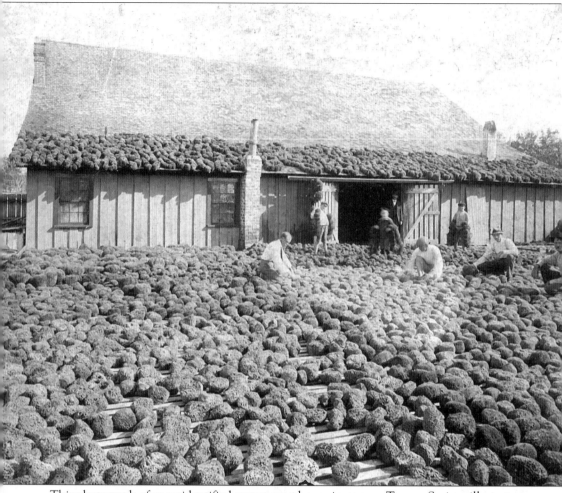

This photograph of an unidentified sponge warehouse in or near Tarpon Springs illustrates one of the last steps in the long and laborious process that turned the fibrous skeletons of small sea creatures into useful, saleable commodities. In the early years of the industry, the first steps in the process took place in the kraals or on the sponge boats. Live sponges are covered with tough, black, fleshy skin and filled with soft gray matter, called gurry. After their harvest, fishermen squeezed, pressed, and stomped out the smelly gurry and stripped away the sponge's rubbery outer membrane. After days of intermittent washings and sun drying, the sponges were ready for auction. The sponges shown here were purchased at a Sponge Exchange auction and transferred to this warehouse, where they were sorted, trimmed, and spread to sun dry on raised wooden platforms. Even the warehouse roof has become a drying surface. The yard workers pause from their task of continuously turning the sponges to pose for the camera.

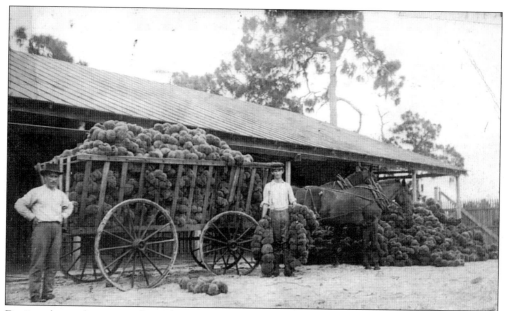

During the early years, when the sponge auctions took place at Bailey's Bluff, sponges were afterwards transported to Tarpon Springs's packinghouses in horse-drawn, rack-sided wagons like this one. Sponge wagons were a common sight at the exchange and sponge docks through the 1920s. Costas Tsourakis stands on the left near the wagon.

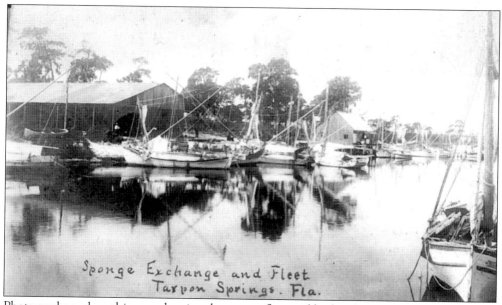

Sponge Exchange and Fleet
Tarpon Springs. Fla.

Photographs such as this one, showing the sponge fleet and harbor from across the glassy water, capture the picturesque appeal that has made the Tarpon Springs sponge docks area an enduring attraction for tourists. The large building on the left is the Sponge Exchange, which underwent many renovations as the industry expanded.

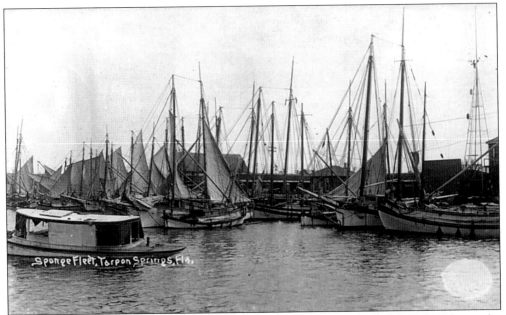

This dense forest of masts and schooners is a striking record of how the harbor looked during the heyday of the local sponge industry. By 1936, Tarpon's 200-vessel sponge fleet, one of the largest in the world, was working from Key West to Apalachicola, harvesting $3 million worth of sponges annually.

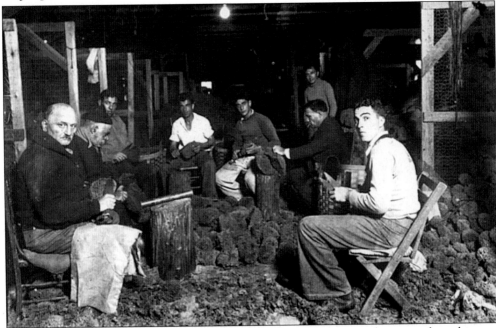

During the 1920s and 1930s, scores of Tarpon Springs men sat in warehouses such as this one, sorting and trimming sponges. When a lot was transferred to a warehouse, workers separated the "cuts," or larger sponges that would be cut into pieces, from the "forms," the small ones to be left intact. Sponges can grow to be over three feet wide. As early as 1901, Florida law prohibited harvesting any sponge smaller than four inches in diameter.

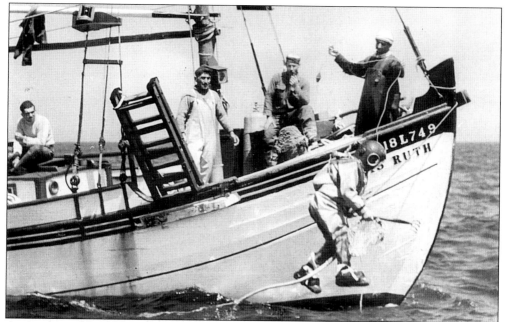

As seen here, divers entered the water armed with a sponge hook, a knife, and a net to hold the sponges. Each boat typically carried two divers, who alternated two-hour shifts. Their job was dangerous and demanding. They faced the threat of sharks and divers could drown or suffocate from a cut or kink in the air hose. By rising too quickly, they could also experience depression sickness, known as "the bends," an excruciating condition that can cause death or paralysis.

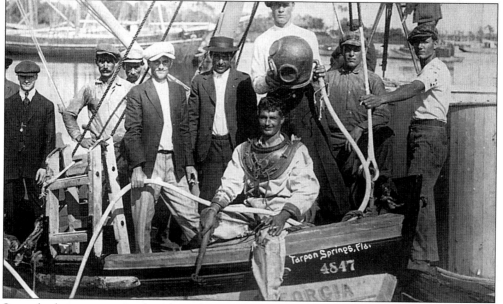

Several adventure movies based on the sponge industry were filmed in Tarpon Springs. *The Diver* appeared in 1932. *Sixteen Fathoms Deep*, based on a story by Eustace Adams, first appeared in 1934, with a remake coming out in 1947. This is the publicity photo used for the original 1934 filming. In 1953, Twentieth Century Fox produced *The Twelve Mile Reef*, which was based on the rivalries between the Key West hook spongers and Tarpon's Greek sponge divers.

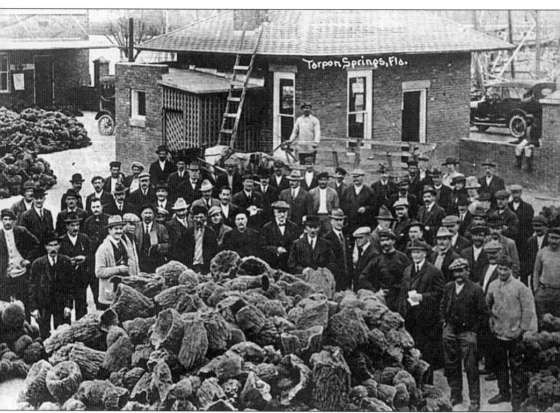

When this photograph was made in the early 1920s, the sponge business was generating an estimated 2,500 jobs. The Sponge Exchange, the setting for this picture, was at the very heart of the industry. To squeeze this large group into a single picture, Tarpon Springs photographer Hayes Bigelow recorded the scene from above, setting up his camera at an appropriate distance on a neighboring rooftop. He may have been documenting a special occasion, or simply photographing the dealers, boat captains, and onlookers gathered to inspect the sponges, which had been piled into lots for the auction. There are thousands of varieties of sponges, but only a few have commercial value. The Gulf of Mexico produces only four commercial species—the sheepswool, grass, yellow, and wire sponges. Among those, the softer, smoother sheepswool sponge is the most desirable and expensive. At Tarpon's Sponge Exchange, sponges have always been sold by the traditional Greek silent auction method. Dealers submit written bids and lots are awarded to the highest bidder.

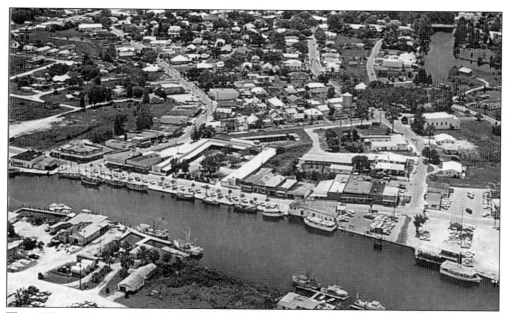

This 1960s aerial view of Tarpon Springs shows the changes that modernized the sponge docks area and Sponge Exchange over several decades. In the 1920s, the city constructed a concrete seawall along the docks. The old Sponge Exchange building, significantly altered over time, was replaced in 1939 by the large concrete structure seen here. Most of the exchange was torn down in the 1980s and a shopping center was built in its place.

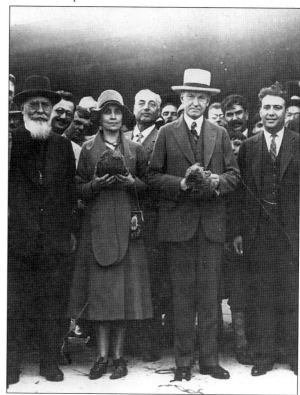

As the unique attractions of Tarpon Springs became more widely known in the 1920s and 1930s, many celebrities touring Florida made stops in the city. Former President and Mrs. Calvin Coolidge, seen here holding souvenir sponges, were the city's most prestigious visitors in 1930.

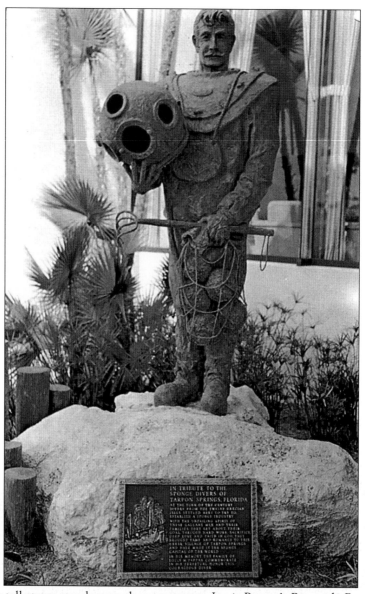

This 10-foot-tall statue stands near the entrance to Louis Pappas's Riverside Restaurant near the sponge docks on Dodecanese Avenue. Created by Stavros Chrysostomides, the statue is a tribute to Greek divers. Its plaque reminds tourists of the important role that these men played in the city's history and in making Tarpon Springs the sponge capital of the world during the 1930s and 1940s. A combination of circumstances brought an end to that heyday. For several years, beginning in 1939, a series of blights spread through the Caribbean and Gulf of Mexico, destroying or diminishing sponge beds. In addition, after World War II, Mediterranean dealers, trying to recover from wartime losses, flooded the American market with cheaper sponges. The local industry never recovered after 1947, when Red Tide devastated sponge beds, sales plummeted, and many boats and workers left the business. By the time sponge populations began to recover, the introduction of synthetic sponges prevented the industry from ever regaining its former importance. Although harvesting and selling sponges still play a role in the local economy, tourism is now the principal business in Tarpon Springs.

Six

GREEK COMMUNITY AND CULTURE

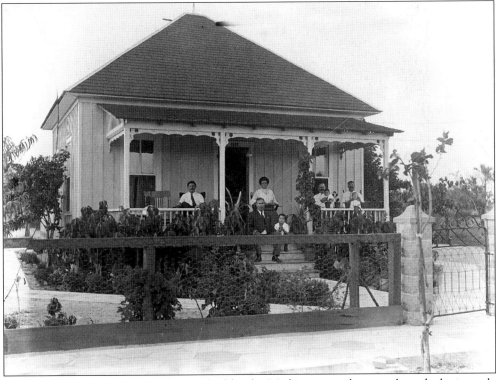

Tarpon Springs was permanently enriched by the Mediterranean heritage brought by its early Greek immigrants. By the 1910s, "Greek Town" covered several blocks behind the Sponge Exchange. This *c.* 1913 photograph shows the family of Costa and Kaliope Moutsatsos at home on Lemon Street. Their modest, but attractive frame house, which was likely painted blue and white, was typical of their Greek neighborhood. Costa, who owned a bakery on Athens Street, came to Tarpon in 1911. His brother Spero came in 1905.

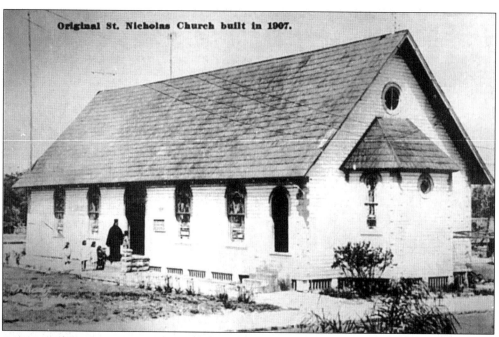

Original St. Nicholas Church built in 1907.

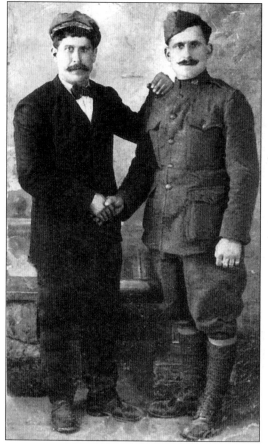

By 1907, Tarpon Greeks had set up a parish community, brought a priest from Kalymnos, and built a church. St. Nicholas Church, named for the patron saint of mariners, was the first Greek Orthodox Church in the city. This is an early photograph of the modest wood structure located at the corner of Hibiscus and Orange Streets. This building was twice damaged by fire before being replaced by a new church in 1943.

This photograph, taken *c.* 1919 in Marseille, France pictures brothers Nicholas and Efthemios Kavouklis. Nicholas served in France with the 81st Wildcat Division during World War I. Born on the island of Kalymnos, he immigrated to Tarpon Springs in 1910 at age 17. Brother Efthemios, on the left, moved from Kalymnos to France. This photo commemorates a remarkable chance meeting of the brothers on a street in Marseille.

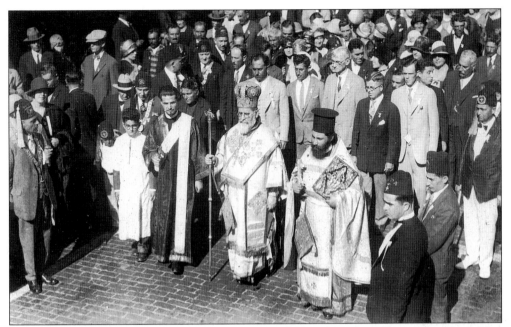

Since their arrival in the city, Tarpon Greeks have celebrated Epiphany Day on January 6. This now famous event, the most elaborate of its kind in the country, begins with a Divine Liturgy at St. Nicholas Cathedral. Following the service, as seen in this photograph, the officiating clergy and dignitaries lead a colorful procession to Spring Bayou for the blessing of the waters.

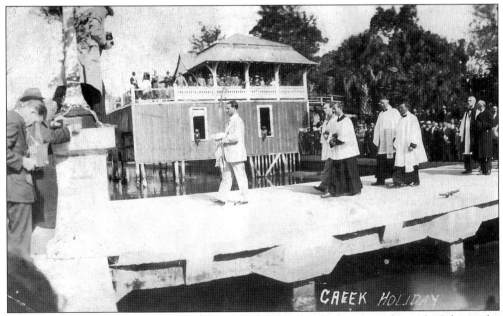

In the Greek Orthodox Church, Epiphany commemorates the baptism of Jesus by John in the River Jordan, when the Holy Spirit descended upon Jesus in the form of a dove. As early as the 1920s, when this photo was taken, the ceremony was attracting thousands of spectators. Press photographers, such as those on the far left in this picture, helped bring national attention to the annual event.

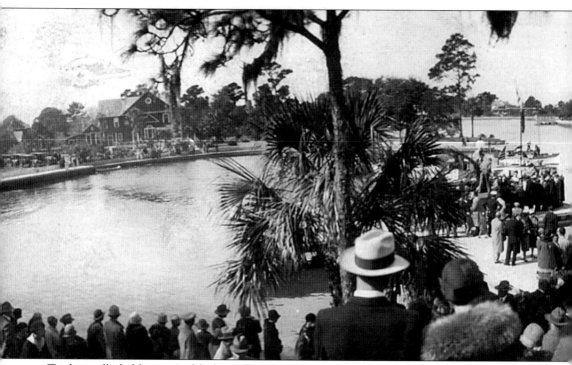

Traditionally led by an Archbishop, the Epiphany procession proceeds to the gaily-festooned Spring Bayou pier where thousands of spectators have gathered. A young girl dressed in white,

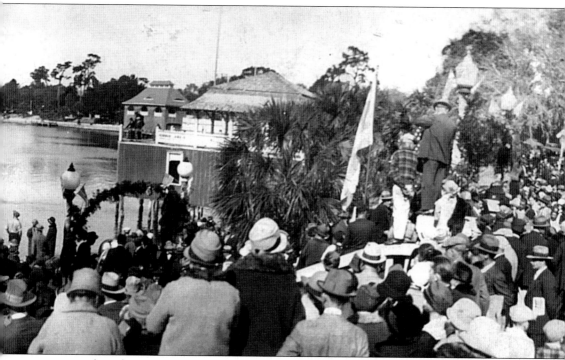

carrying a white dove, is part of the procession. As a result of national attention given to this event over the years, Tarpon Springs is known as "Epiphany City."

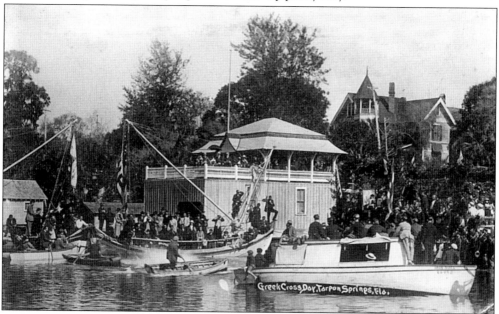

At Spring Bayou the Archbishop blesses America and Greece and then reads the Bible story of Christ's baptism. As the reading concludes, the young girl releases the dove, symbolizing the descent of the Holy Spirit. In early Epiphany celebrations, priests performed the ceremony at the bayou from boats or floating platforms. That may have been the practice in the Epiphany Day recorded in this c. 1914 photo.

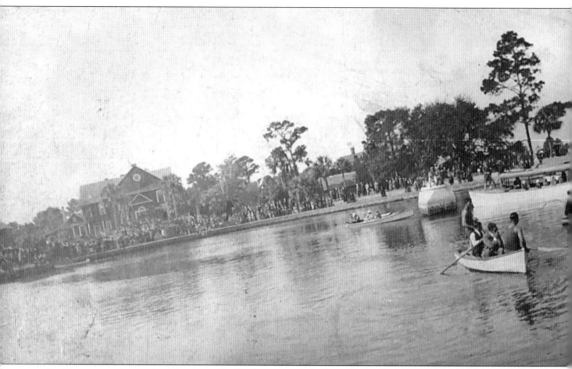

In Tarpon springs, the Epiphany holy day is popularly called "Greek Cross Day," a reference to the most eagerly awaited event of the ceremony. After the release of the dove, the Archbishop, or presiding priest, throws a gold cross into the bayou waters, symbolizing the

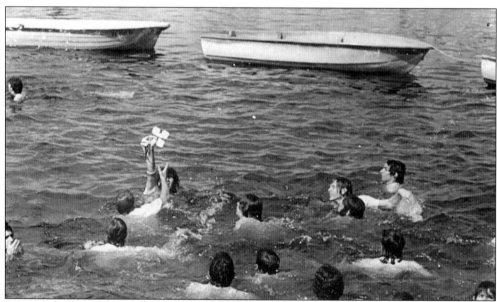

Diving from small boats arranged in a semi-circle, 50 or so teenage boys plunge into the chilly January water, hoping to retrieve the cross. In the Epiphany ritual, their competitive struggle is viewed as a symbol of man's struggle for truth. In this photograph, the hero of the day has just emerged, triumphantly hoisting his cross above the water.

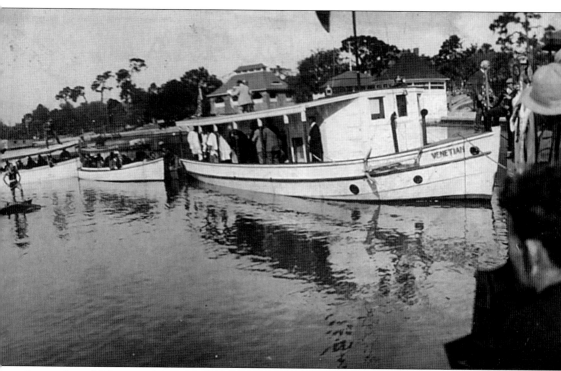

immersion of Christ in the water. This panoramic view of the bayou shows several small boats occupied by the young Greek men who will attempt to retrieve the cross.

The young man who retrieves the cross returns it to the Bishop and kneels to receive the Bishop's special blessing. Participants believe that this blessing assures the recipient a life of good fortune. Anthony Houliris, shown here, was the cross retriever in the 1938 Epiphany ceremony.

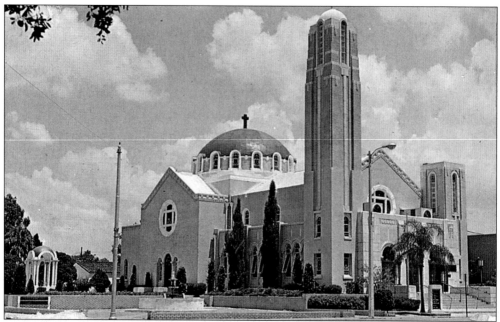

In 1943, the old Greek Church was replaced by St. Nicholas Greek Orthodox Church. Many individuals and groups contributed to the building fund, which began in the 1930s. Every sponge boat pledged a percentage of its profits to the cause. The Greek community's dedicated efforts created this beautiful building, designed to resemble the famous church of Hagia Sophia in Turkey (now a museum). The round arches, massive dome, and bell tower are hallmarks of its impressive Byzantine style.

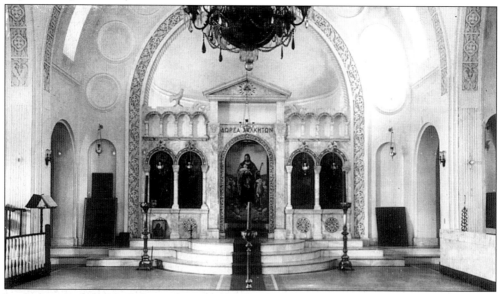

Looking toward the altar, this early view of St. Nicholas Church shows its original interior as it appeared in 1943. A gift from the Greek government, the 15 tons of marble used inside the church were shipped from New York, where they had been part of the 1939 World's Fair Exposition. The interior was also adorned with three massive chandeliers made of imported Czechoslovakian glass.

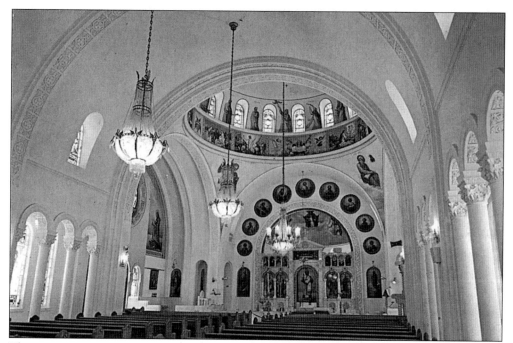

This more extensive interior view of St. Nicholas Church shows the early 1950s mural paintings of saints and apostles by well-known religious artist, George Saclarides. Some of the church's 23 memorial stained glass windows are also visible here. In 1976, the Greek Orthodox Archbishop of North and South America designated St. Nicholas Church as St. Nicholas Greek Orthodox Cathedral.

St. Michael's Shrine is a small chapel that is open to the public and located on Hope Street, not far from the Greek Orthodox Cathedral. The chapel was built by a local Greek family in the 1940s as a token of their gratitude for their young son's miraculous recovery from meningitis. Many people visit the shrine to pray or leave religious or personal mementos.

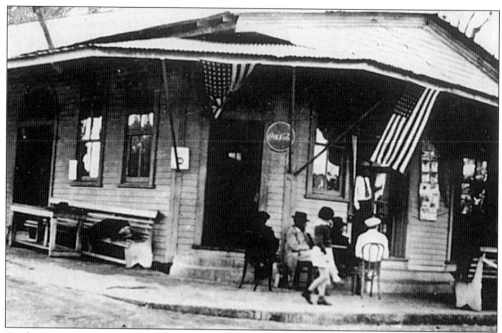

As the sponge industry flourished, the sponge docks area took on the noisy colorful character of a Mediterranean port city. Greek merchants recreated the tastes and traditions of their homeland. Spongemen gathered at cafes such as the coffee house in this *c.* 1930 photograph. Opened in 1913 by Lazarus Kavouklis, brother of Nicholas Kavouklis, this popular Athens Street establishment was operated for some 70 years by members of the Kavouklis family.

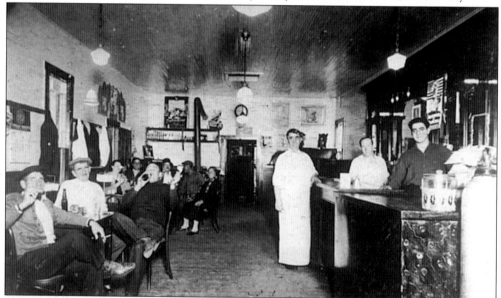

In the 1920s, tourists began to discover the unique cultural experiences of the sponge docks area. Those seeking authentic Greek cuisine were not disappointed. One of the most popular among the Greek restaurants springing up at that time was this establishment opened by Louis Pappas in 1925. The present Louis Pappas's Riverside Restaurant, built in 1975, is among the city's most well known landmarks.

In the 1910s and 1920s street vendors sold sponges to Tarpon Springs tourists. Irene Gianiskis opened the town's first souvenir shop in her home. By the 1930s, small curio and souvenir shops such as this one were doing business all along the Greek waterfront on Dodecanese Boulevard.

Because Tarpon Springs for many years had the largest concentration of Greek immigrants in America, numerous dignitaries from Greece visited the city in the 1920s and 1930s. This 1922 photograph documented the arrival of Greek Premier Eleutherious Venizelos (center) and his wife. The Premier is flanked by prominent local citizens. Jane Tulumaris (bottom left) and Goldie Saclarides (bottom right) hold flowers they later presented to the visitors.

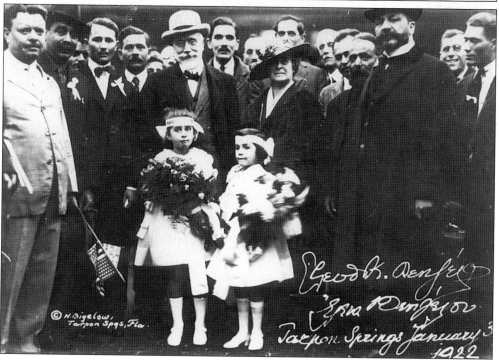

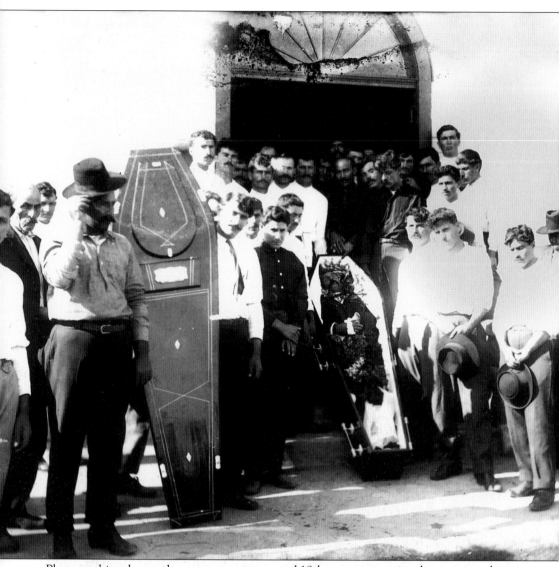

Photographing deceased persons was an accepted 19th-century practice that continued in many cultures well into the 20th century. It was a common practice for years in the Greek community of Tarpon Springs. In addition to being sentimental family mementos, photographs like this one would be sent to relatives back in Greece as evidence of the person's passing. This scene, with female mourners noticeably absent, was recorded just outside the door of the old Greek Church.

Seven

UNIQUE LOCAL ATTRACTIONS

This novelty of nature, known as "the wedding tree," occurred when the trunk of a pine tree grew through the trunk of an oak. A popular tourist attraction, the tree was located near what is now Live Oak Street. During the 1890s and early 1900s, the tree was a favorite site for picnics and weddings. It was such a cherished local landmark that its location is marked on an 1890s city map.

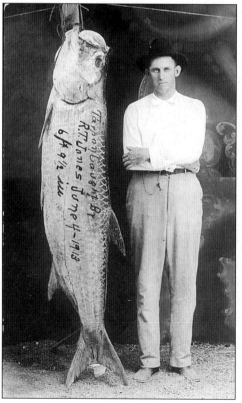

Cherokee Cottage in bignonia season was another unique must-see for Tarpon Springs tourists. Located at the corner of Lemon Street and Pinellas Avenue, across from City Hall, the small house was hidden beneath a tangle of vines and blossoms from the dense growth of a massive bignonia plant. The winter home of Dr. and Mrs. William Morgan, the cottage was reportedly a spectacular sight when bignonias were in bloom.

This image is among many curious early photos used to promote Tarpon Springs as a fishermen's paradise. Its caption reads, "The 6 foot 2 inch Marshal and 6 foot 4 inch Tarpon." Ruben Jones, the lucky angler, was the marshal of Tarpon Springs from 1906 to 1919. The tough controversial Jones wore a badge made of $20 gold pieces. He was gunned down in 1921, and his murderers were never apprehended.

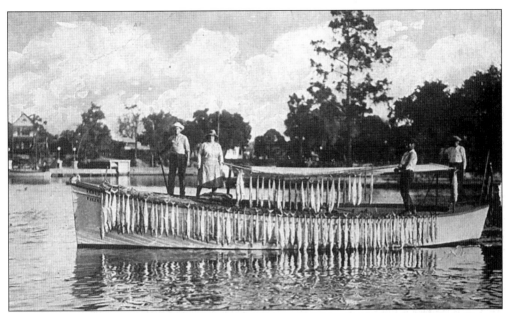

As early as 1885, ads describing the "Newly Opened" West Gulf Florida extolled Tarpon Springs for "fishing, such as sportsmen never dreamed of." Another early account of the area concurred: "It abounds so much in fish, that a person may sit on the bank and stick them with a knife or stick as they swim by." Photographs such as this 1930s postcard view helped perpetuate the area's enduring reputation as a fisherman's mecca.

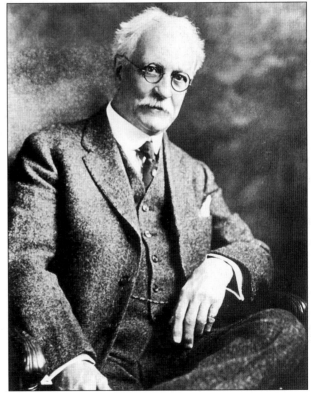

George Inness Jr. was the most widely known celebrity in Tarpon Springs. His father, who spent time in Tarpon Springs in the 1890s, was George Sr., one of America's most important 19th-century landscape painters. George Jr. also became a painter, initially studying with his father and later in France. By 1895, he was developing his own distinctive style working in Paris under the influence of the Barbizon landscape painters.

Inness Jr. and the former Julia Goodman Smith, his wife, pose here with friends at Camp Comfort, their place on the Anclote River. The Innesses were popular members of Tarpon's winter colony of wealthy cultured Northerners. The painter, wearing a tall Mexican hat, kneels at the center of the group. His six-foot-tall wife stands on the far right. Inness was known as a gentle fun-loving person and his wife gave generously to local causes.

In 1902, the Innesses bought this home on West Orange Street, where George Sr. had wintered in the 1890s. Over the years, they transformed the modest two-story house into a rambling, eclectic 27-room home with 11 porches. Some of the additions housed young artists who came to study painting with Inness Jr. New owners have recently removed the various additions to restore the house to its original 1895 appearance.

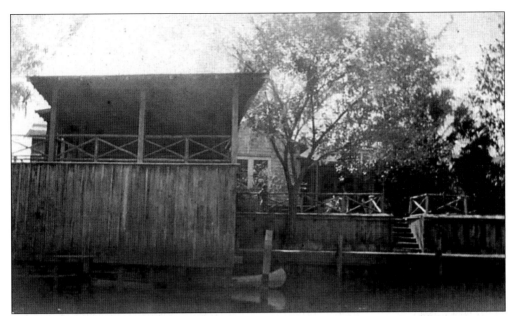

Inness's second studio, an appropriate retreat for a landscape painter, was located in this rustic hideaway called Camp Comfort. Inspired by the beautiful natural setting, he had this cottage built in a remote area on the Anclote River shore about 10 miles above Tarpon Springs.

Inness executed this large work, *The Lord in His Temple*, at his long-time summer home in Cragsmoor, New York. As the title suggests, the artist sought to convey a religious spirituality through his serene paintings of nature, known for their luminous, "living greens." He completed this work shortly before his death in 1926. Mrs. Inness presented it to Tarpon Springs Universalist Church in 1927. (Courtesy of the Universalist Church, Tarpon Springs, Florida.)

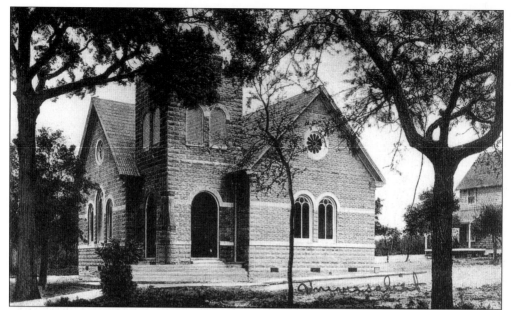

The Innesses were devoted members of Tarpon's oldest church, the Unitarian Universalist Church, founded in 1885. Still located in this 1909 building on Read Street, the church houses a prized collection of 11 Inness paintings. The first paintings were acquired by the church in the early 1920s after Inness executed them to temporarily replace the stained glass windows destroyed by the 1918 hurricane.

In addition to mystical nature views, Inness painted large canvases depicting religious or biblical narratives. This 1899 work, *The Last Shadow of the Cross*, is one of his best in that genre. He executed this painting while working in France in the late 1890s. It won a medal there and hung in the Louvre for years before being presented to the Universalist Church in 1926. The Inness collection is a major tourist attraction. (Courtesy of the Universalist Church, Tarpon Springs, Florida.)

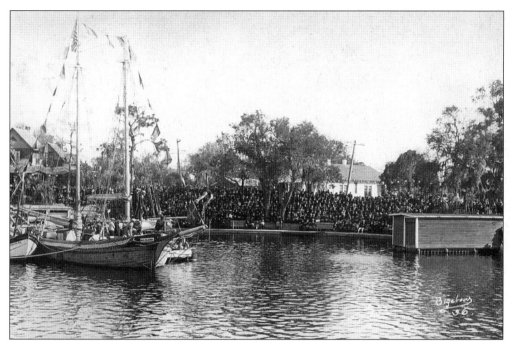

As illustrated here, the Epiphany ceremony was not the only winter event that brought thousands of people to the banks of Spring Bayou in the 1920s. Indeed, the most spectacular community projects of that decade were the three bayou festivals held in February in 1924, 1925, and 1926. The ambitious festival was called "Tarpon Springs Annual Water Sports Carnival and Illuminated Fleet Parade."

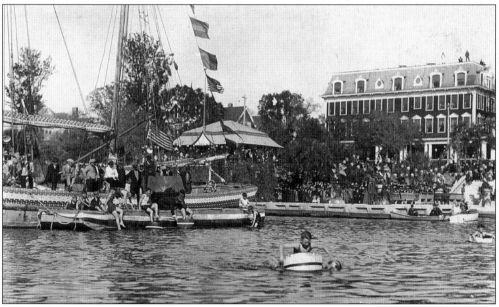

For dedicated spectators coming for all events, the Water Carnival was an all-day and evening outing. The afternoon schedule included boat races and other competitive water events designed for all ages. This scene, with the Tarpon Hotel in the distance, shows contestants in the popular children's barrel relay races.

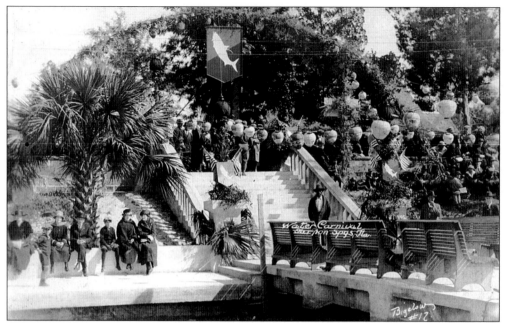

Local committees put forth enormous efforts preparing for the annual carnivals. In addition to constructing grandstand seating on the banks and bayou perimeter, the pier and areas surrounding the bayou were lavishly decorated. This photograph of the pier's entrance and steps suggests the carnival atmosphere created by the array of brightly colored banners, Japanese lanterns, and hundreds of paper flowers made by Tarpon Spring ladies.

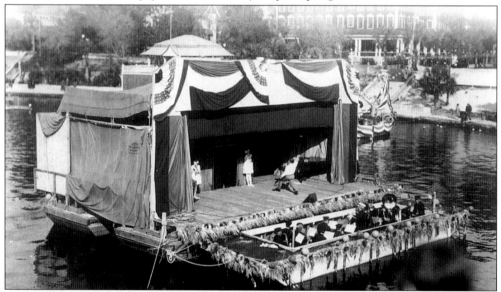

Two barges lashed together created a stage for the festival's musical and theatrical performances. Entertainment varied from operas and plays performed by professionals, to local band numbers and gymnastic routines performed by local schoolchildren. In 1924, the Tampa Community Players performed *H.M.S. Pinafore*, and, in 1925, they performed *The Mikado*. The planning committee was particularly ambitious in 1926, when a Metropolitan Opera cast performed *A Midsummer Night's Dream*.

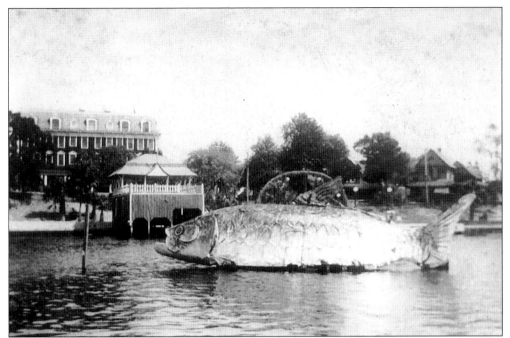

The "Illuminated Fleet Parade" was the climax of the festival. In this much-anticipated after-dark event, floats were revealed to spectators as they passed through a series of huge spotlights. A giant swan, Neptune and his train, and Cleopatra's barge were some of the most popular themes depicted. This photograph shows another local favorite—the "Silver King Tarpon," a float built by Arthur R. Kaminis at the Anclote Shipbuilding Co.

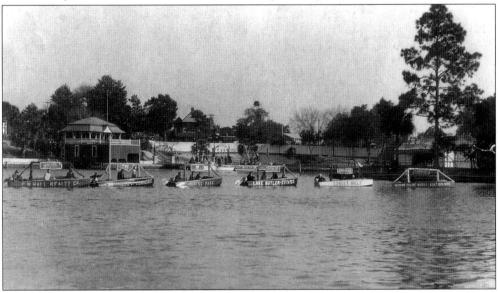

Since the water festivals were in part an effort to bring visitors—and their money—to Tarpon Springs, it is not surprising that several local businesses used the occasion to advertise their services. This line-up of boats, bearing banners that together read "Tarpon Springs Venice of the South," may have been the opening act of the festival. In addition, each boat sported a painted sign advertising a local business.

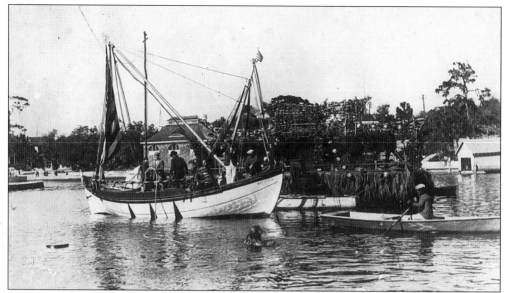

If local townspeople considered sponge divers a familiar sight, that would not have been the case for the many winter tourists who came from around the region to Tarpon's water carnivals. As seen in this photograph, Greek crews brought their colorful sponge boats right into Spring Bayou, where festival crowds enjoyed a unique opportunity to observe sponge-diving exhibitions. The diver's helmet and shoulders are visible in the water.

A hand-written caption tells us that these well-dressed young people were "participants" in the carnival as "guests on Harry Lewis' parade yacht." The significance of the trophies is unknown. To the disappointment of many, the carnivals did not continue after 1926, when a commercial firm had taken over the floats and decorations. Unpredictable weather and waning local energy for the laborious preparations were generally blamed for the carnival's demise.